my cool shed.

# my cool shed.

an inspirational guide to stylish hideaways and workspaces

**jane field-lewis**

photography by **tina hillier**

**PAVILION**

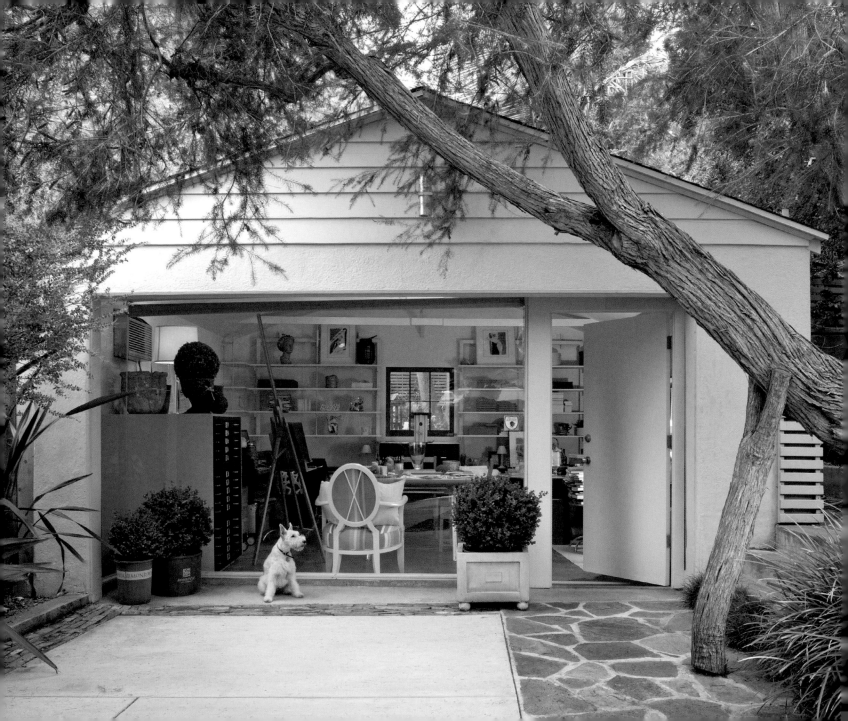

# contents

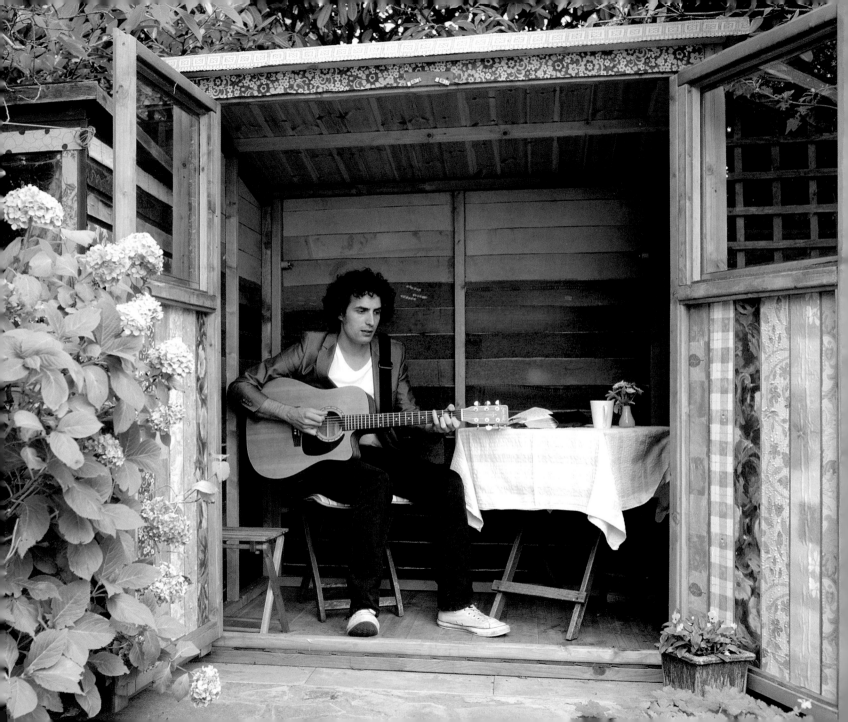

# introduction

*my cool shed* is all about escaping to a place of our own, where we have the space to create, draw, paint, write, rest or simply get away from our busy lives and concentrate on what's important for us. All the sheds and cabins included in this book provide their owners with the means to separate themselves from their everyday life and all its routines. These themes echo those running through my two previous books, *my cool caravan* and *my cool campervan*, which celebrated individuality, the pursuit of an alternative lifestyle and the creation of one's own little private hideaway.

This book is all about having your own personal space, in a separate building from your home, styled and decorated as you wish, along with the opportunity to work or relax in your own way. The sheds featured have served their purpose well. They are highly considered small spaces, which are owned by artists, writers, gardeners, musicians, environmentalists, craftsmen, designers and small businesses, providing them with an important seedbed for independent thought, greater creativity and achievement.

An intrinsic part of their charm is that normal decorating rules don't apply and they give their owners the freedom to express themselves in a different way. They embody the spirit of the new style, which has an unexpected beauty and doesn't necessarily follow fashion or trends – it is rooted in individuals, their values and belief systems. Given this choice, people don't necessarily follow convention; they create their own environment, often with unexpected and refreshing design ideas and consequences.

We are becoming more selective in our choices, rejecting the old approach of buying a complete look to create an instant perfect-looking world, including the values that are implicit in the material things. Instead, we are opting for authenticity, seeking out furnishings and decorative objects that have personal significance. Recycled, vintage and precious items are mixed with new, functional and practical ones. This, in itself, creates its own story and connects us to a lifetime of experiences and memories.

Similarly, the art of styling has changed in an exciting way as set pieces are replaced by a more observed look, which recognizes the owner's interests and values. This new aesthetic is reflected throughout this book in the featured sheds, cabins, studios and workrooms. The owners have developed their own environments as well as a highly personalized 'look'. Whatever its purpose, their personal space needs to feel right as well as look right. By gaining an insight into how other people have carved out their spaces to suit their particular needs, I hope that you can be similarly inspired in your own endeavours.

Tina Hillier and I travelled extensively to fill this book with words and images. I am grateful for the journey and to the wonderful people who welcomed us into their personal spaces, some of which are visually idyllic or even world-renowned. It was a joy and a privilege to take a closer look at these private worlds, some extravagant, others simple and frugal, and to connect in some way to the extraordinary people who have created them.

This book is all about what people do to fulfil their dreams of expression and escape. In doing so, they sometimes create unexpected aesthetics and design. Styling with soul is the common thread that unites all these diverse shed owners – there is always a good reason why things look and work the way they do. There is even something delightful about the eccentric collections of the small things in life that are loved and valued and which their owners cannot bear to throw away. John Earl, for example, has kept his children's plastic toy figurines; these charming objects are on display in his 'songs from the shed' as well as being utilized as impromptu styling features in his garden paving.

I hope that this book inspires you, not just in design terms but also in seeking and finding the ideal space in which to work or take time out to relax or even transform your whole life. Sometimes, adopting a more idiosyncratic and personal approach is the route to finding real solutions; creating an inspiring space, whether it's on the seashore, out in the wilds or at the bottom of your garden, can help you achieve what you wish for. This is the miracle that the contributors to this book already know and treasure.

As Tina Hillier, our talented photographer, rightly said one day on our travels: 'Why would you not want a shed? It offers a simple, affordable way of following your dreams'. Try it out for yourself and see what happens.

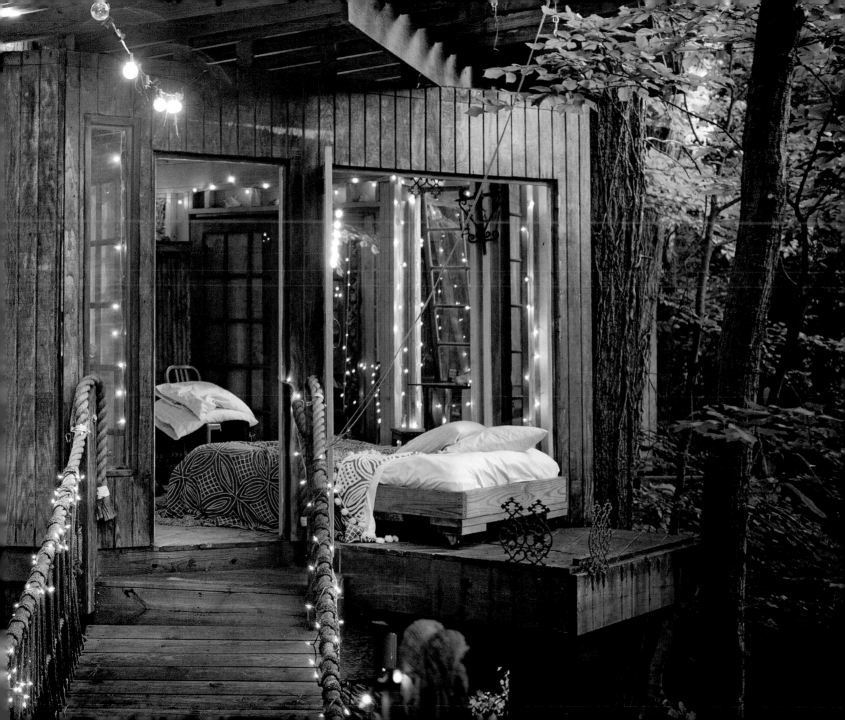

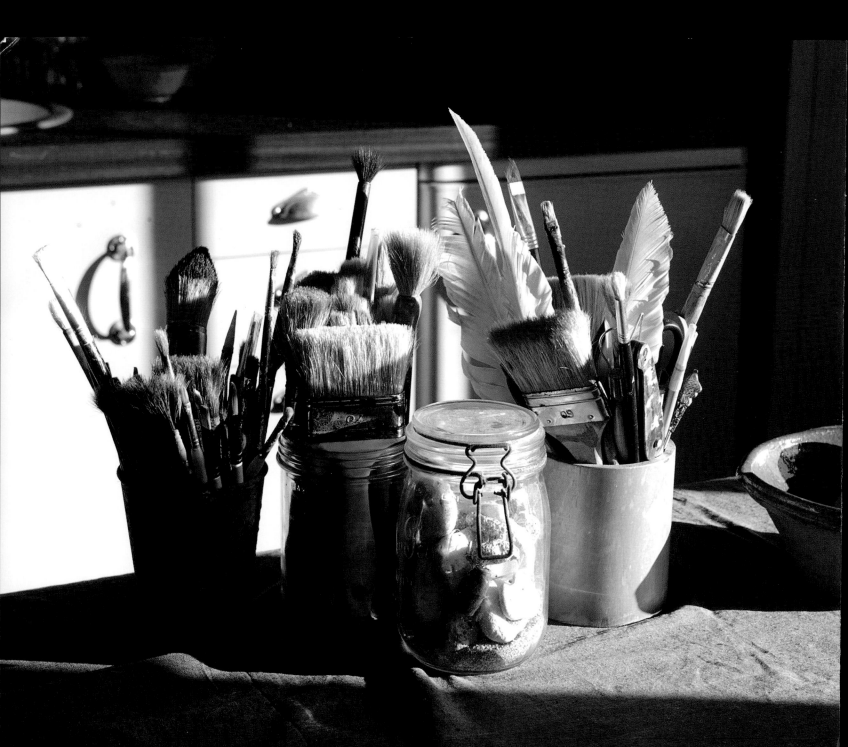

# **artists**

Many artists are drawn to small spaces where they can feel free to work intensively away from the distractions of everyday life. In order to focus exclusively on the creative process, some need to separate themselves from conventional routines, whereas others are inspired by the cross-fertilization of ideas that comes from working within an artistic community.

The sheds featured are extremely diverse in their construction and design but they are all practical working studios for their owners. The quality of light is a key component, and there are some interesting insights into how different artists have adapted or improved the natural and artificial lighting to suit their individual needs. Another universal strand running through this section is the range of storage methods for working tools – all the artists like them to be at hand, in an easy and convenient fashion, but limited space has sometimes forced them to focus on devising ingenious solutions.

For all the artists featured, the creative environment is equally important, and the idiosyncratic spaces they have conceived are as unique and personal as their art itself. They range from a small piece of wartime history – a renovated inner-city air raid shelter – to an incredibly stylish purpose-built studio at the end of a pier above the Atlantic Ocean. For artists with garden studios, they represent the opportunity to be closer to the natural world.

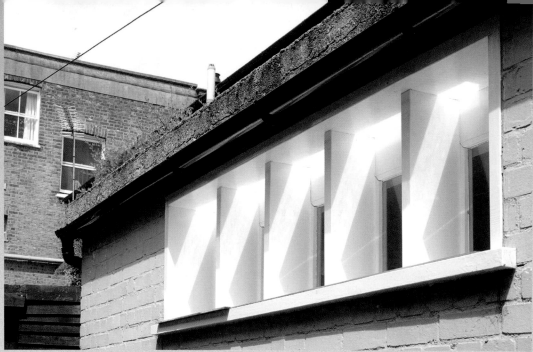

# air raid shelter

Thanks to Ian Lettice, an idiosyncratic relic of our social history has found a new lease of life as a working artist's studio. Ian discovered the abandoned air raid shelter in Putney, southwest London, while taking his children to scouts on the same site. Intrigued, he removed a panel from the battered door and forced his way into the dark, dank interior, where he discovered 'a candy floss' of spiders' webs. The shelter had been built in 1940 as a safe haven from German bombs, but at the end of World War II it was boarded up, forgotten and hidden from view until Ian stumbled upon it 50 years later and had the brainwave of transforming it into a studio. Low, squat and flat-roofed with thick, sturdy walls, the shelter had no windows or natural light, but Ian's vision, resourcefulness and sensitive restoration soon overcame these obstacles as he set about creating a unique working space.

Ian believes that old industrial buildings can still be useful to new generations if they are converted imaginatively. His focus throughout the renovation process was on reusing old materials and keeping the design simple and true to its origins. He rescued the floorboards from a skip in Fulham, and he made the window frames from some mezzanine floor joists found in a Wandsworth warehouse. The bookcases were fashioned from the existing small partition wall, and a minute 'kitchen' area was created using a salvaged workbench.

It was hard work cutting through the thick walls to install the windows, but although they had stood up to the Blitz, they were no match for Ian's sledge hammer. The result is well worth all the effort – a functional, simple studio with its own quiet integrity, which provides Ian with the space and solitude he needs as a figurative artist.

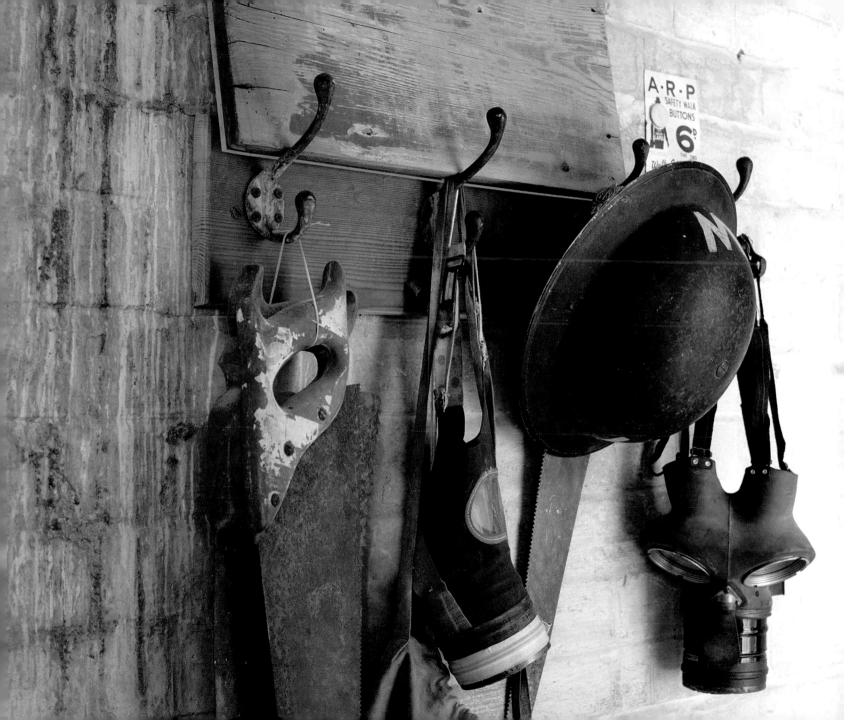

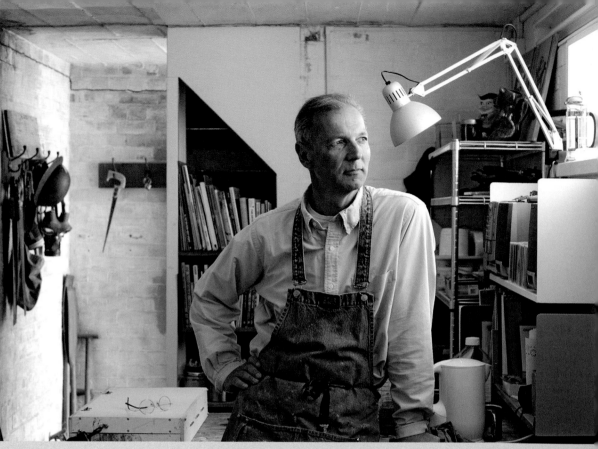

## style notes

A surprisingly luminous and comfortable space has been created from what was formerly a functional, austere and dark interior. Ian carefully cut square windows high into the south wall to flood the studio with natural light. He recycled the original oak bunks into wall panels, only leaving the entrance area in its unpainted, distressed condition in homage to the original shelter. The walls were lined with narrow shelves to support a complementary mixture of his local riverscapes and still lifes. Together with a few original artefacts – some gas masks and a tin hat – they adorn the hallway and enhance this warm, engaging space. In the kitchen area, a primus gas stove, some modern chrome mugs and an old biscuit tin provide a natural, homely feeling.

Neat and orderly in design and function, Ian's studio is an honest reminder of times past, demonstrating the value and endurance of a sturdy structure. It has been painted simply in neutral colours to provide a blank canvas for exhibiting Ian's paintings, whose individual creativity is the primary decorating source.

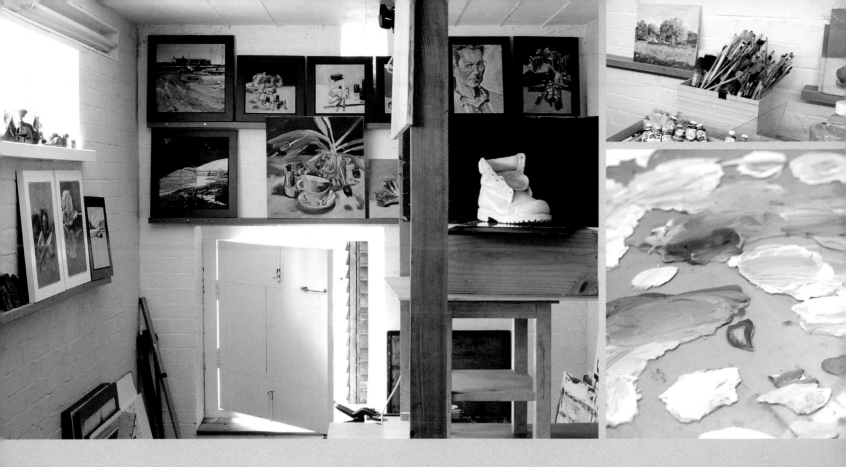

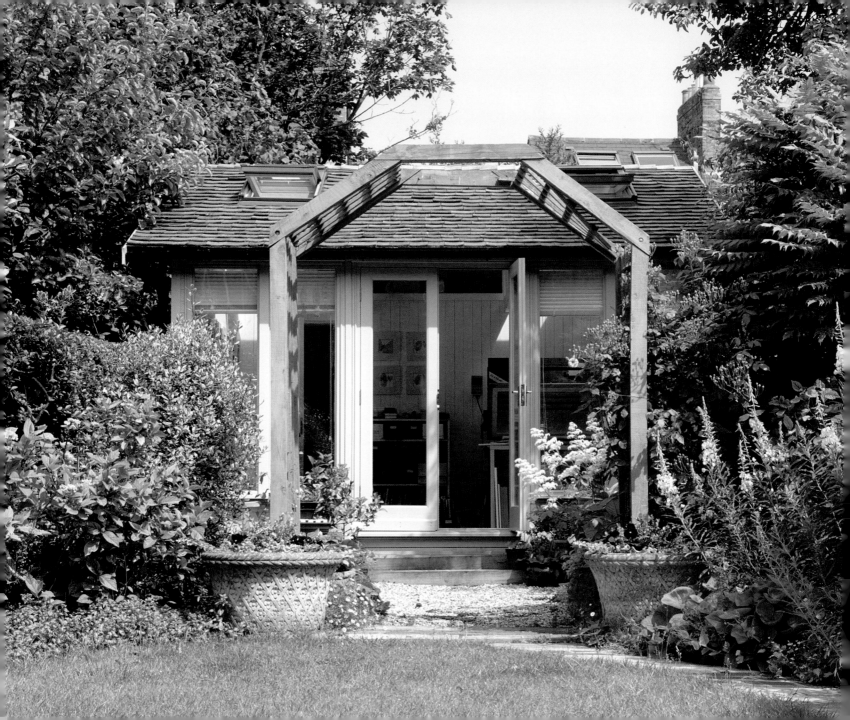

# glass studio

Wendy Newhofer, the winner of the 2010 Mary Moser prize, pursues her second career as an artist working in fused glass in her charming garden studio. Formerly a primary school teacher, she came across an ad in her local newspaper for a part-time art foundation course and discovered her passion for kiln-formed glass, whereby precious metals, in wire and fine copper, aluminium and silver metal leaf, are sandwiched between clear sheets of glass. When they are fired, the metals emerge in a subtle, delicate palette and the full image develops.

Wendy says that 'having the studio informs the work I do'. Her creativity is inspired by a combination of botanical drawings with their attention to detail and her own observations of the plants and insect life in her garden. She makes coloured drawings from still-life compositions of bottles, butterflies, moths and seed-heads, which are transformed into framed glass images and large decorative bowls and platters.

Wendy's first workplace was a coalhole between the basement and front steps of her Oxford home, but with an inheritance from her mother she decided to honour her memory and love of gardening by building this garden studio. Her mother would have been proud of the development of Wendy's artistic career and the studio has become her legacy. Wendy customized a standard off-the-peg garden studio for her work by adding extra windows, and creating an all-glass front wall facing the garden, whilst still allocating some space, tucked away at the side, for traditional garden implements and bike storage. This has become a life- and work-changing place for her. Personally and artistically perfect, she loves her studio and says it is 'absolutely magical'.

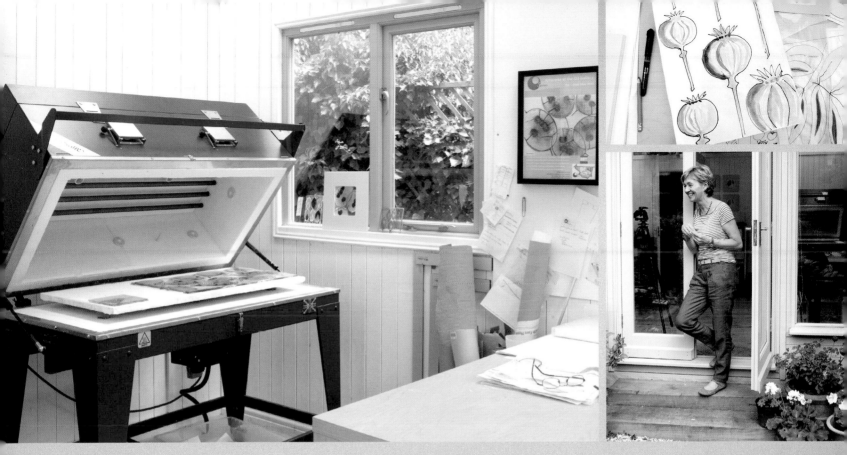

## style notes

Having enough space to house a large kiln was a major consideration for Wendy when she was adapting the studio. She also needed a complete separation from everyday distractions where her creativity could flourish, and a working environment that was flooded with light. This clean, bright interior space fits the bill on both counts: it is full of light and relates immediately to the natural world of her garden just beyond the huge glass windows of the facade.

The pleasing whitewashed walls provide a neutral background for Wendy's artworks and give the building an alternative function as a gallery and exhibition space, enabling her to participate in local artists' 'open studio' events. Thus the perfect confluence of a creative working space and effective display venue for her art has been achieved. Finished pieces as well as work in progress and a variety of brushes, drawing materials and inspirational objects, which are potential future subject matter for artworks, sit tidily on the neat shelves and are propped up on windowsills against the glass panes. Wendy uses them as reference to draw her images while seated at the large work table before committing them to precious metal designs between sheets of glass

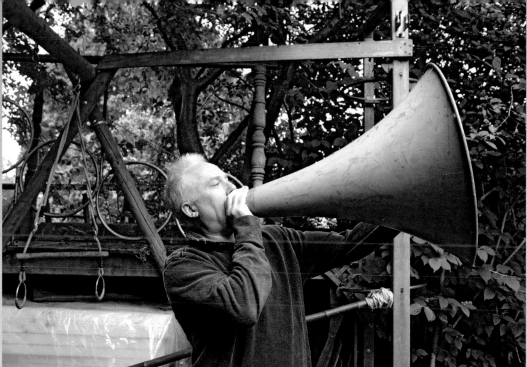

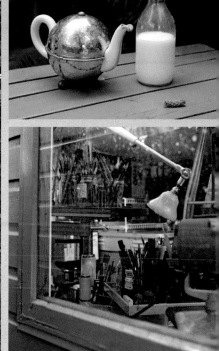

# covenanted shed

The book illustrator and writer Ted Dewan works out of a small shed at the bottom of his Oxford garden. However, this is no ordinary shed: the small wooden building was formerly owned by his friend Phillip Pullman, the author of *His Dark Materials* trilogy, and it came with a signed and witnessed covenant to the effect that it should be used only for creative purposes and must be passed on to another writer, artist or musician 'if it hadn't turned to dust in the meantime'. A copy of the covenant hangs on the wall.

After being dismantled in 2003, the shed was moved from Pullman's garden and re-erected in Ted's. He left the interior walls unchanged with their pretty small floral pink rose sprig design wallpaper, but he did make some modifications. As he needs good natural light for his work, he added two skylights – reclaimed 'crittal' windows from a local factory – and cleverly positioned some mirrored wardrobe doors to reflect even more light into the space. The shed has developed slowly over the years, almost as a living entity, with each new addition having meaning and a purpose. Ted likes to find a new home for unwanted and idiosyncratic items that have outlived their original function and have been discarded by their former owners.

Although it's cold in winter, Ted rejects the notion of modern heating, preferring to work in fingerless gloves and a padded jacket, which make him 'feel like a proper artist who can't afford heat'. This shed fulfils its mission of being a creative, tech-free zone and, in Ted's words, 'a magic box'. There is an important lesson here for us all: to be more flexible and laid back and just let our sheds evolve of their own accord rather than planning them right down to the last detail.

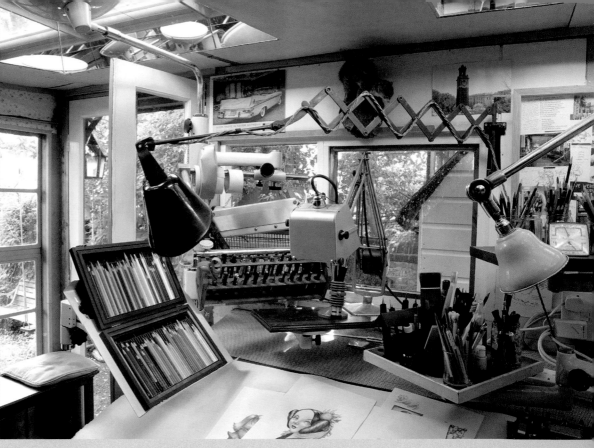

## style notes

There is a genuine free spirit about this place. The shed sits in what Ted describes as a 'junk yard garden' full of found and reused items from everyday life, which are now used as garden sculptures. A nondescript grey metal filing cabinet, which, no doubt, once graced a grey office, now sits amongst the foliage, doubling up as Ted's tool chest.

Inside the shed, a vintage optician's equipment stand with articulated arms has been given a new lease of life. It first caught Ted's fancy some years ago when he cheekily suggested to the optician: 'if you ever think of getting rid of this...' Cream-enamelled and chunkily industrial-looking, it became the multiple-armed, movable equipment stand for his pens, inks, pencils and lamps. Working at his drawing bench, all his art materials are thus within easy reach, ready to be swung into position to use – a truly ingenious solution in a limited workspace, where getting up to find something would interrupt his concentration on the job in hand. Everything is recycled

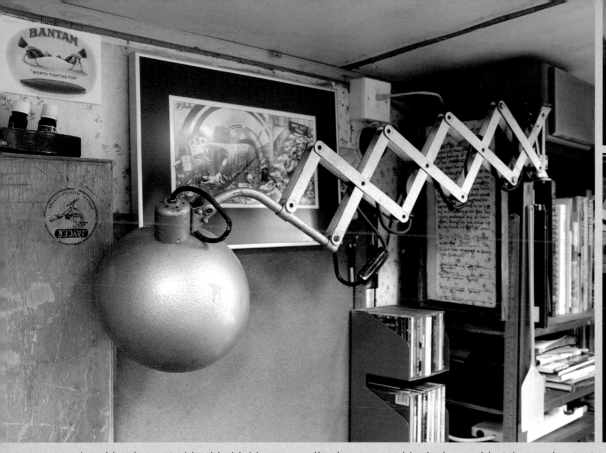

and nothing is wasted in this highly personalized space: on his desk, an old-style wooden test tube rack from a school chemistry lab has found a new purpose as a pen holder.

The walls are covered with small remembrances and triangular embroidered pennants from summer camps in the United States, attended by Ted as a child. A former organist, he has labelled a series of shallow drawers with the names of organ stops whose tonal sound is related to their contents. And all of this is watched over proprietorially by Fran, the taxidermied fox. This eccentric collection of treasures has a humility that makes them all wonderful. The relaxing lack of formality in their composition bestows the overall impression of a happy free-spirit kind of place. Most of the items are used out of context for a new purpose, as long as they serve a function, have meaning and are well made in the first place. There is a real artfulness here, along with a glorious sense of Terry Gilliamesque unexpectedness and ingenuity. This shed is truly blessed and still resonates with the creative spirit embodied in its covenant.

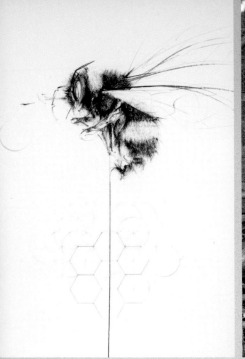

# garden studio

In her end-of-the-garden shed in north London, the illustrator and writer Jessica Albarn can indulge and develop her lifelong fascination with the natural world and its leggy insects, especially spiders and other creepy-crawlies. It is her private sanctuary where she can sit quietly and do most of her thinking for her work. Creativity is a mysterious process, and it sometimes takes time and solitude to get the right flow of ideas and energy. Jessica's custom-built studio has enabled her to engage with nature and augment her creative work.

She describes her shed as 'a lifesaver'. Working from home in this studio meant she could take care of her family and produce her intricate artworks during school days without wasting time on commuting. Her ex-father-in-law built the shed from reclaimed timber and bits and bobs, such as old doors and cast-off oak floorboards – the rest was 'cobbled together' – but it fulfils its purpose admirably, especially as Jessica is a country girl at heart. 'Living in the city, with only a small garden, albeit a slightly wild one, I have to let things grow and settle'; her charming garden studio enables her to draw on nature for her artistic inspiration.

Jessica feels fortunate to own the studio and although she is the first to acknowledge that it's 'rough and ready' and not very stylish, it works well for her on every level. The light is good and there is no shortage of subject matter for her illustrations. Art in progress is pinned up on the walls while finished pieces stand neatly wrapped and labelled, ready to send to her gallery. The rough and readiness is a quintessential part of this studio's charm where even spiders' webs are welcomed and the local insect kingdom is invited to make its home. Ultimately, it is its own living creative space – a big celebration of life's small creatures.

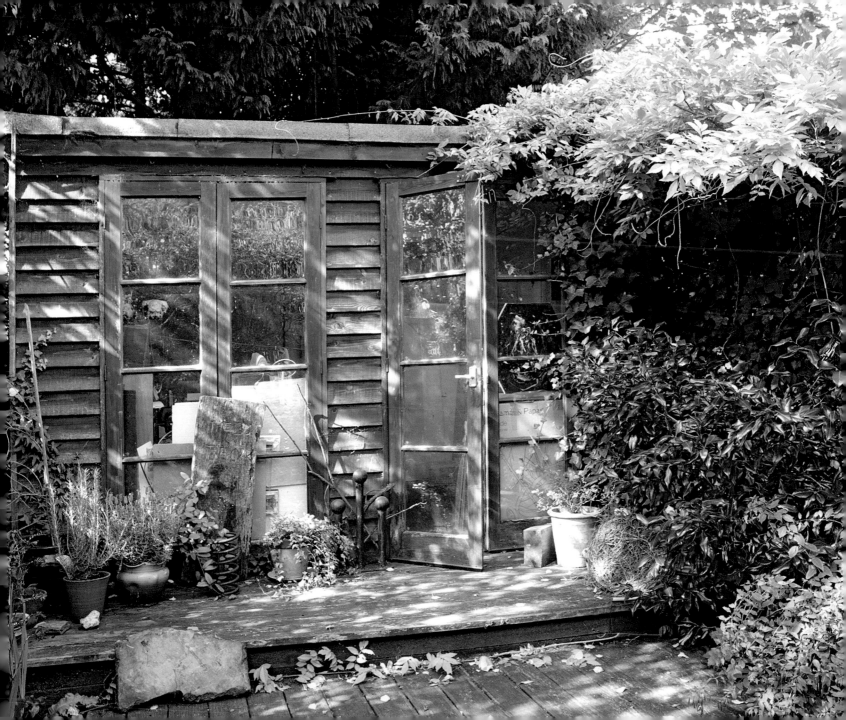

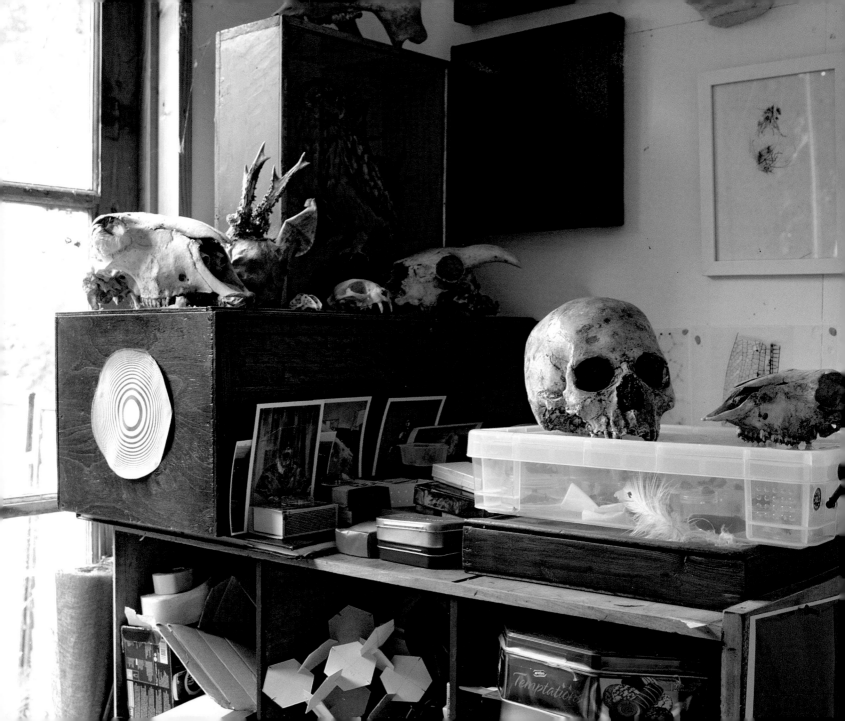

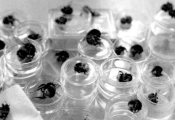

## style notes

Insects, spiders, flies, bees and butterflies – nature in all its glory – are featured in Jessica's beautiful fine-detailed pencil drawings, which have been inspired by the work of Leonardo da Vinci and Francis Bacon. Her shed has become a little universe in microcosm; its big windows bestow a view of the real world outside while, inside, the scurrying spiders spinning their intricate webs in dark corners and the little creatures making their homes in nooks and crannies have become the artist's unwitting models.

The dead are honoured as well as the living – insect specimens donated by kindly friends and a collection of animal skulls are carefully preserved in neat sections in translucent storage boxes. A number of bees sit in their individual little containers ready to be centre stage in a future painting or to feature in an illustration for a book. All these creatures are treasured, looked after and valued. Using specialist magnifying glasses to take a more detailed look at their minute details, Jessica can capture their beauty more precisely and explore their symbolism.

The studio has not been decorated in a purposeful way – it is a comfortable working space that has evolved over time. Look closely and you will notice that the subtle texture of the ageing skulls is reflected in the fine pencil work of Jessica's drawings pinned on the wall. By repealing these nuances elsewhere, the place develops some context and seemingly diverse objects with little in common relate to each other. Palettes that are totally natural toned can often feel flat, but squint at these images and it is the yellow of the butterflies and the spot of pink on the shelf that catch your eye. Just a hint of punctuating colour can break the level palette and add depth and sharpness.

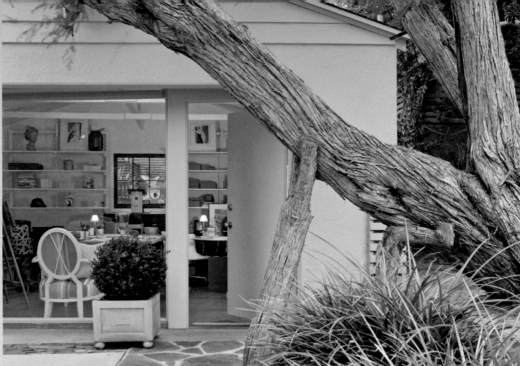

# californian art studio

This stylish studio complements its acclaimed garden setting, which was inspired by the Mojave Desert and the work of Californian landscape designers, such as Jay Griffith. Take a close look at Ann Field's studio and you will see the telltale signs of its original use as a garage. Local planning regulations stipulated that the driveway should remain and be usable, and that the large plate glass window that replaced the original metal roller door must be the same size to facilitate its conversion back to a garage, if so desired. Ann's brief to Morphosis, a local architectural firm, was to create an interior space that was light, simple and timeless. In addition to the large sheet of plate glass, a glass door and skylight were added to maximize the light, and the rough wooden walls were lined with plasterboard and painted white. The architect even designed the storage unit and desks to create an overall proportional 'look'.

However, life moves on and as Ann's career has developed, the building has evolved from being solely a painting studio, messy with paints, pastels, canvases and easels, to a multi-functional space. With the advent of new technologies, Ann embraced the digital world and now her studio is truly multi-purpose: a painting studio, a writing office and a presentation space for meeting clients. And outside of working hours, she can restyle it for entertaining her friends around the big table. For Ann, 'it's a revolving environment for my favourite things and a gallery of artwork on display for inspiration'. The proof is in the pudding, and this distinctively Californian space has happily embraced its own metamorphosis. After 20 years of adaptation to Ann's evolving career needs, it still feels fresh and she is happy with the design concept.

## style notes

Although this inspirational place is home to the creation of some of the most notable pieces of modern sculpture, it is refreshingly unintimidating and, despite its cultural importance, it has a surprisingly restful atmosphere. Graced by the famous clear light of St Ives, it feels like a little piece of heaven. The ambience of the studio and gardens is so infectious that even though you may have no skills or talent as a sculptor, you still find yourself wanting to 'have a go'. Hepworth worked in an instinctive way, her forms determined to some extent by the nature and character of the material she was using. To achieve this, she needed to be 'in the flow' and in comfortable harmony with her environment, and her studio enabled her to do this.

A sculptor's eye misses nothing and falls on every minute detail in their world: the beautiful organic shapes in the sculptures are echoed in the choice of furniture and planting. The Sea form (Porthmeor) 1958 sculpture in the conservatory, with its organic

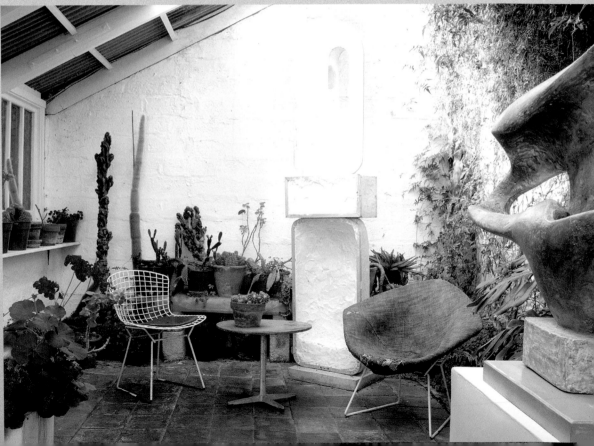

stretched breaking wave shape, is also referenced in the form of the deliberately placed Bertoia Diamond wire chair from the same period, its upholstered grey textured cover adding to this relationship. Bertoia himself was an artist and sculptor turned acclaimed furniture designer. Similarly, the simple, almost monastic single bed and chair in the whitewashed summerhouse relate both in their tone and shape to the white hunks of stone, standing ready and waiting to be carved.

The trend for all-white interiors has been huge over recent years, but here's the way to make it work without a space looking bland or dull. In the studio, there are many tones of chalky white – add to this a range of textures, such as the painted stone wall, the smooth mirror and the wooden slats of the simple door, and that's how to make white feel homely and comfortable.

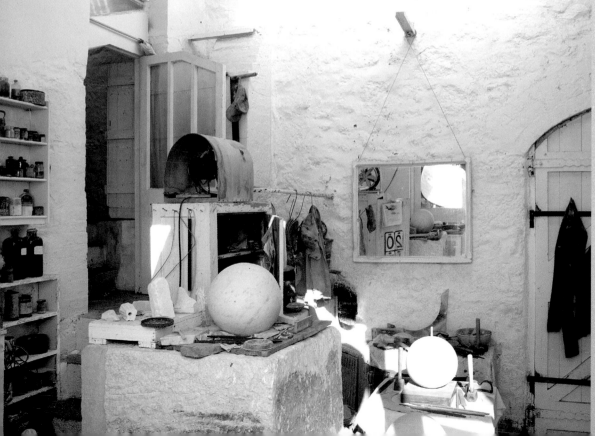

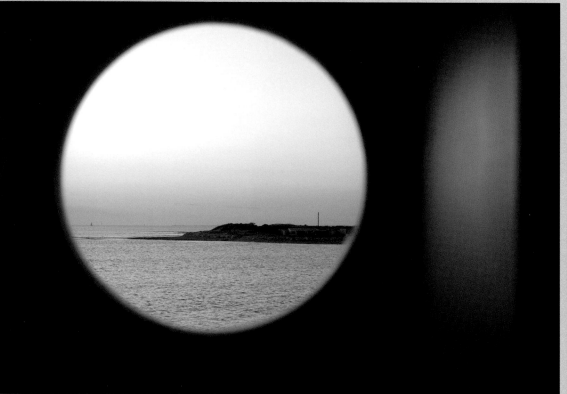

**38. my cool shed**

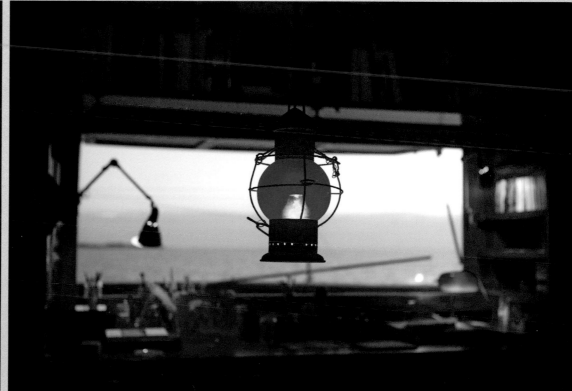

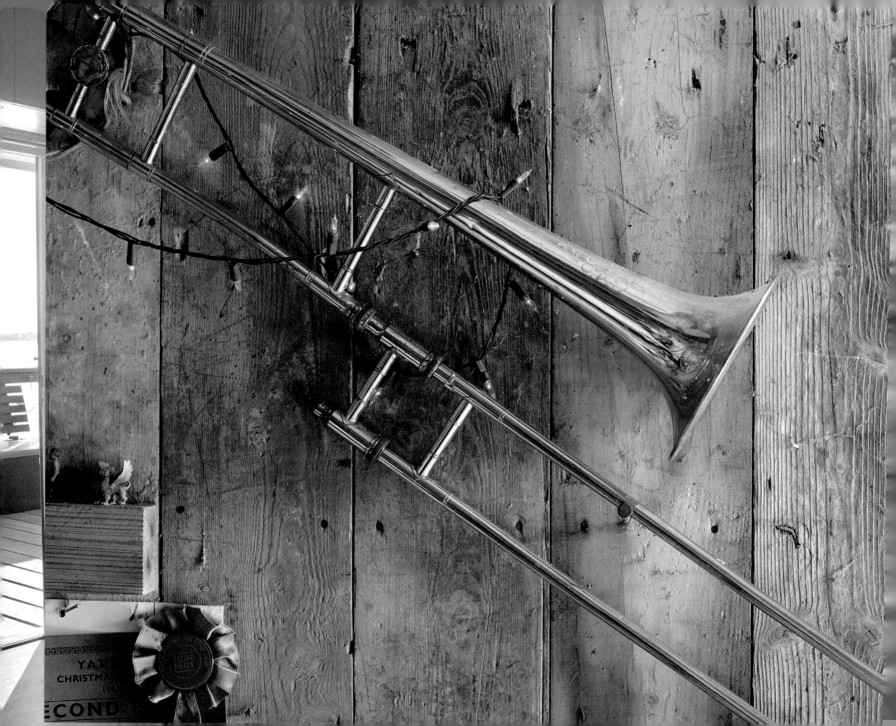

# musicians

Most of us don't associate musicians with sheds, but the artists featured in this section have all ended up working in their own idiosyncratic wooden cabins and have been inspired by their environments and experiences.

Songs from the shed is one man's expression of his love of acoustic music. If viewed out of context, the idea of turning a garden shed into a music venue seems ridiculous. However, when you consider its wonderful acoustics, the owner's genuine commitment to real music, and the integrity of the music production, then it isn't so strange after all. This is genuine back-to-roots music, recorded with simple technology and loaded onto the internet for everyone to share. The line-up of musicians, from established names to new artistes, who want to perform in this unassuming shed is ever growing.

The quirky and truly individual 'shed songs' is a unique collaboration between a textile artist and a young singer/songwriter. The shed itself, with its exterior and interior surfaces covered with applied re-cycled materials, is the physical manifestation of an ongoing art project. It is purpose built to be portable, thereby becoming a movable music venue.

And, finally, the humour expressed in the music of the Dutch musician and comedian Hans Liberg is also represented in his custom-made, modernist squared-off log cabin, which he uses to compose and produce his shows. When it is closed up, it is virtually indistinguishable from a neat log pile, but when the window shutters are opened up, it resembles a birdwatcher's hide or look-out. It is both witty and clever and a work of art in itself.

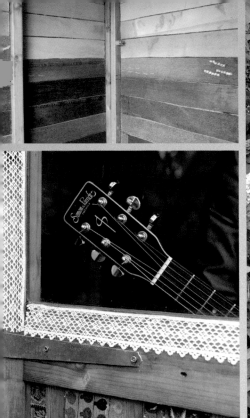

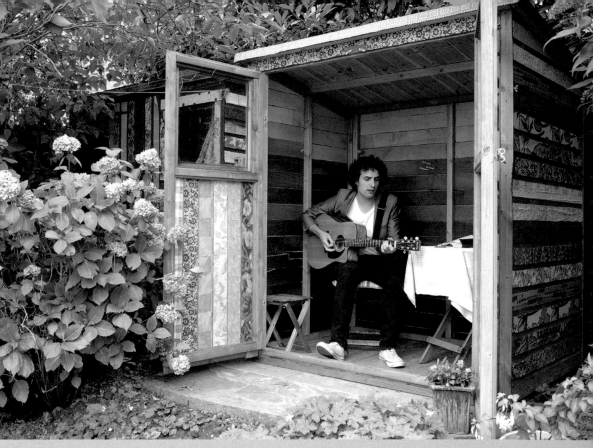

# shed songs

Elena and Dan's shed is a work of art with its cornucopia of colours. Whereas most people paint their garden shed a conventional brown or green to blend in with their garden, Elena has done the exact opposite, covering hers in a rich patchwork of wonderful vintage florals, which reflects her passion for embroidery. The fusion between the linear nature of her patchwork and the wooden shed appealed to her artistic nature and the idea for this unusual shed was born.

Other projects quickly followed when an appeal on the 'shedblog' yielded a pair of allotment sheds ripe for a makeover. Elena's friends loved the idea, too, and one even asked her to decorate a dog's kennel in a similar style. When she met the musician and songwriter Dan Whitehead, Elena took the concept further. Dan wanted to perform his songs against a shed backdrop and they decided to create a fabric-covered shed as a unique performance space. Their mission was to construct a building that could be assembled, disassembled and transported to different venues for Dan's concerts. A local company was commissioned to make the basic structure and, after some early glitches, a simple solution was found. With the help of some long wing nuts, screws and old wooden cotton reels, the shed comes apart easily for transportation.

## style notes

This highly unusual shed is part art project and part performance space and has been a successful outlet for both Dan's and Elena's creative output – a fabulous expression of Elena's embroidery and a great way of engaging people artistically and musically. The doors are covered with a cheerful mix of strips of fabric from Elena's vast collection. They all have a familiar and universal quality, so you come away feeling as though you have seen them elsewhere. The prints used are accessible and not intimidating – far from it – they are the prints of our everyday lives. Dan says that the shed 'attracts the right sort of people', and Elena's choice of fabrics achieves this subliminally. Her work is immaculate, detailed and infused with meaning.

The interior walls are covered with tonal strips from about 25 pairs of old jeans. Stuck on with PVA glue, the darker tones graduate towards the base of the shed, so they become progressively lighter as they climb the walls. It isn't obvious at first glance that the fabric is denim but a closer inspection reveals its texture. The overall effect is restful, vaguely reminiscent of the seaside.

And, unlike other sheds, this building is organic and forever evolving. The pretty narrow lace strip across the top is a good example of this transformation process; this latest addition was made necessary because last year's fell off in a hard frost!

# modern log cabin

Hans Liberg likes working in small rooms and, drawing inspiration from Le Corbusier's cabin (see page 68), he set about commissioning his own tiny 2 x 4m studio – a space that is perfectly adequate for his needs. An unusual mix of pop and classical music – from Lady Gaga to Schubert – appeals to this accomplished musical artist, composer and comic, and his studio reflects this eclectic approach. Although the design is modern, things are not quite as they seem and the cabin resembles a log stack, a bird watcher's hide or even a woodpile on a trailer.

Hans approached Piet Hein Eek, whose work he had always admired, to design the cabin. He was interested in Hein Eek's philosophy of using only waste materials. He loved the idea that space could be enclosed to the point where it became invisible. When Hans approached him, Hein Eek told him wryly that he doesn't normally do what his clients want but he would consider it! Due to restrictive planning regulations, the only structure permitted had to be impermanent and mobile, and this log cabin fulfils the brief. It sits square on the ground, its wheels concealed by wooden logs. With the shutters lowered, it looks like a heap of logs, rendering it invisible; when they're raised, it resembles a bird watcher's hide. Like a real log pile, nature loves the cabin and Hans can hear the repetitive pecking of a woodpecker on the outer walls as he works.

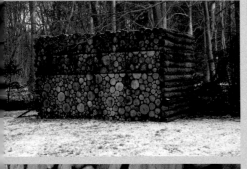

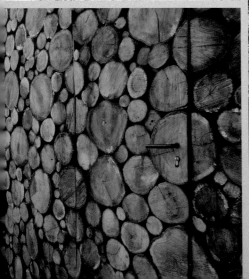

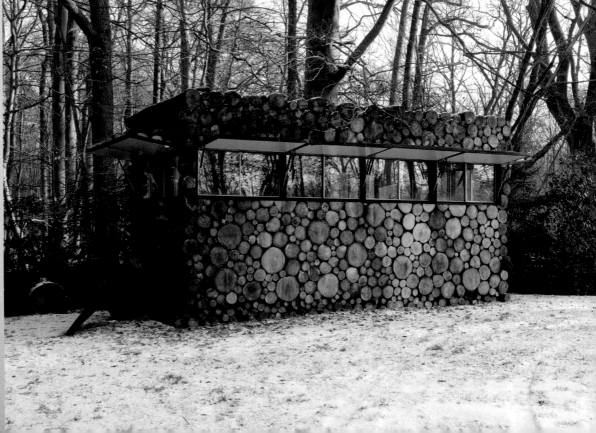

## style notes

Outside, the cabin's highly textured and warm-toned exterior is designed to blend into its woodland habitat, camouflaging its purpose; inside, there is a similar simplicity. Being faced with a multitude of paint colour charts can make it difficult to decide what to choose and where to start, but the designer of this modern log cabin gave Hans a simple choice for the interior: grey or blue. He chose the calming, sleek light blue – a quiet colour 'like heaven'. The simple surfaces are treated as a whole, free from any unnecessary details and painted in one unifying colour. It takes Hans three months to create each musical and comedy performance and a further three months to produce it, so he needs an inspiring working environment without distractions.

In contrast with his main residence, which houses his vast art collection and which he describes as 'robust and vibrant', this studio is simple and functional. Everything has been reduced to the basic essentials: a keyboard and a small radio – there aren't even any speakers. The basic table, designed to be at the right working height for the keyboard, is a nod to 1940s' style. It doesn't take itself too seriously; a sense of humour, wit and surprise lie just beneath the surface. The chairs are made by the cabin's architect, Hein Eek. They are part of his 'Crisis' collection and are specially designed to retain their elemental, hand-crafted provenance.

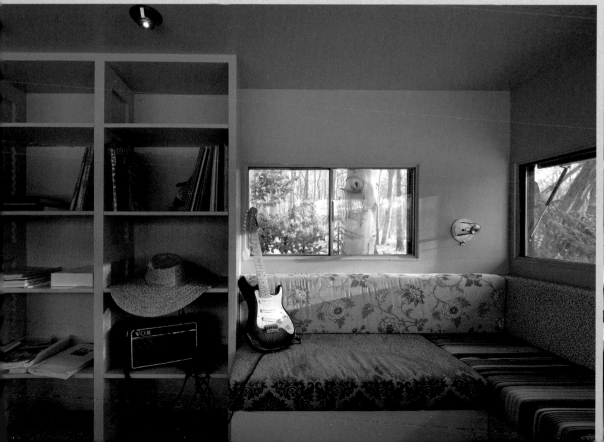

## style notes

Jon is part artist, part magpie. Entering his shed, you experience not only a sense of freedom but you are also aware of the unexpected and its limitless potential. There is an exciting element of surprise as you realize that you're not quite sure what you're going to hear or see. The unpretentiousness and lack of artifice extends beyond the music and the recording techniques to Jon's decoration. When he acquired the shed, four years ago, the previous owner (a butcher) had left some mementoes behind: prize certificates from a local agricultural show and a few rosettes. Instead of throwing them away, Jon has treasured them and added more bric-a-brack in a haphazard kind of way.

Visually random, yes indeed, but the interior of the shed is actually quite neat and tidy, and, in truth, a more meaningful collection would be hard to find. It is a happy juxtaposition of items, each with its own special history and personal meaning. A ship in a bottle was the first gift that Jon's son bought for him with his own money; the wooden dresser, which came from Jon's former house, didn't fit into his new one; and the old fishing floats belonged to his uncles. The eccentric collections of plastic toy creatures were once his children's pride and joy. There are old cameras, fake flowers, colourful Christmas lights and a darts board... all small things, of no monetary value, but each with its own story and memories.

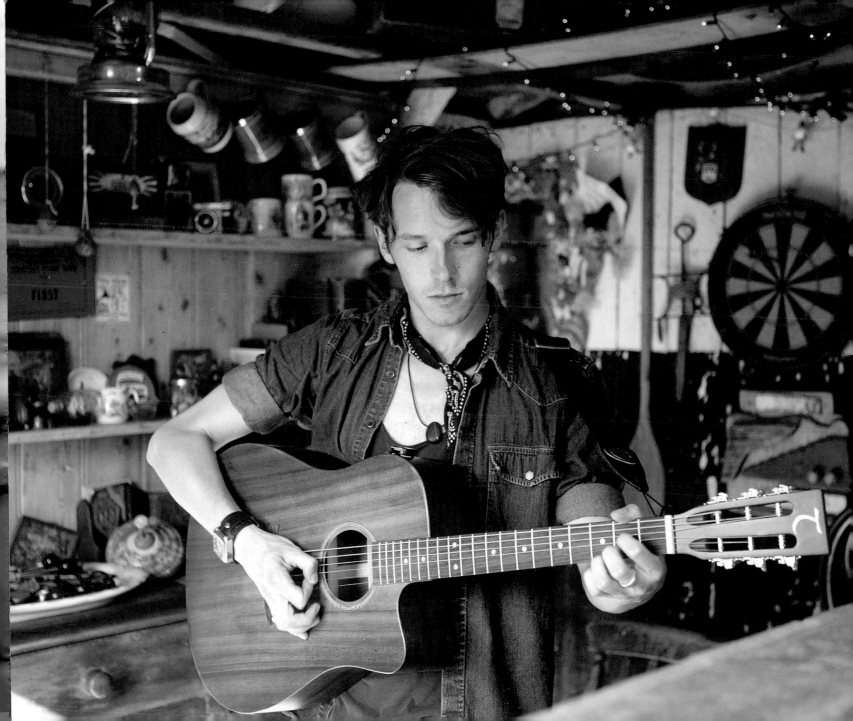

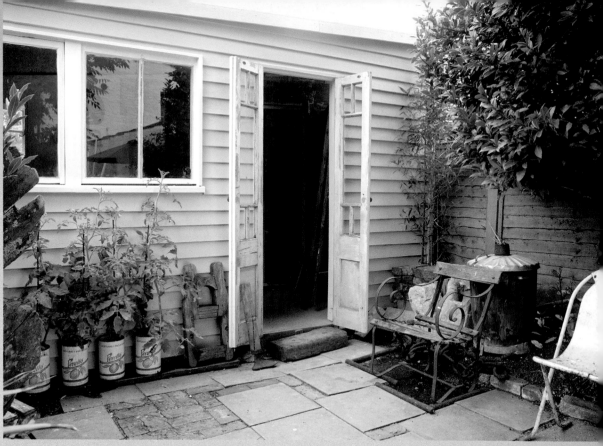

# ben's shed

'A wedge of cheese with a blunt end' is how Ben describes his handmade shed, which is made from reclaimed materials. Nestling in his back garden in the pretty Victorian seaside town of Whitstable, it was designed to fit the available space, and the original back gate, providing essential access for building materials to avoid traffic through the terraced house, is integrated into the shed's back wall. Not an inch is wasted in this cleverly devised site-specific design.

Ben uses the shed as a retreat from family life as well as a creative space where he can pursue his love of high-end carpentry. He values the quality of his raw materials, especially wood, and collects and hoards old timber – the older it is, the better he likes it. He regards it as sacrilege to discard a good piece of old oak or mahogany and keeps it until he has a use for it.

The structure was dictated by the available materials, most of which Ben had acquired and saved for reuse when the opportunity arose. The walls are clad with small oblong pieces of roughly planed wood, reclaimed from fine wine boxes; the French doors were rescued from a skip; and the windows are the original sash ones from Ben's house but hinged from the top. Naturally, the original lead sash weights were too good to throw out and they have acquired a new lease of life as a temporary garden-edging device between the paving and flowerbeds.

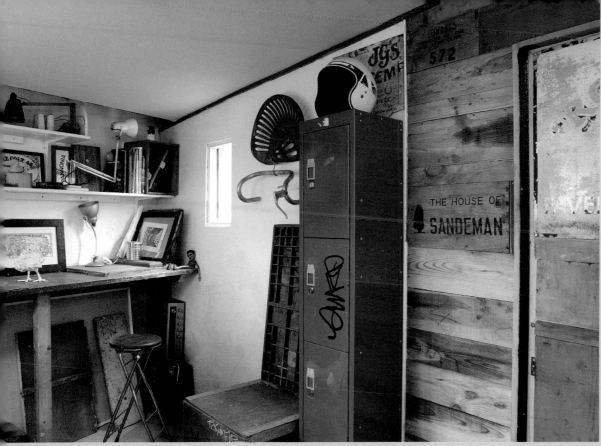

## style notes

The cohesive use of aged materials, in their natural forms, is striking in this seaside bolthole, endowing it with a simple elegance of colour, tone and texture. They are used as an artistic form of patchwork – the roughly hewn natural palette has small areas of red, black and yellow with all the incidental pieces working together to add elements of sharpness and punctuation.

Ben doesn't try to restore things to their original state of perfection – he likes them naturally worn and shabby. Around a floor of simple poured concrete is an abundance of natural textures, genuinely distressed by age and circumstances. The varnish on the surface of the familiar dark mahogany workbench, which once saw duty in a school science laboratory, is patchy and scratched. It is well worn from dozens of chemistry experiments, scratched by teenagers scraping their initials into the timber, and roughly polished by countless weary elbows.

During his career as a graphic designer, Ben discovered his love of typefaces. This is echoed on the sides of the wooden tea-chests used as cladding for the back doors, and on the storage box that once held a bottle of vintage port. There is even an antique American tractor seat with the manufacturer's name set in heavy embossed type. Elsewhere, old paperback books are recycled to create small sculptural pieces, and a plaster, wire and papier mâché bird sits on the workbench – a million small stories and details lurk behind these seemingly everyday objects.

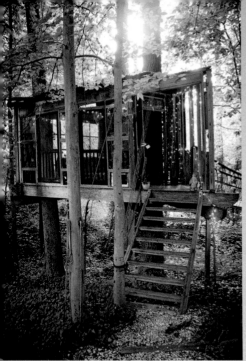

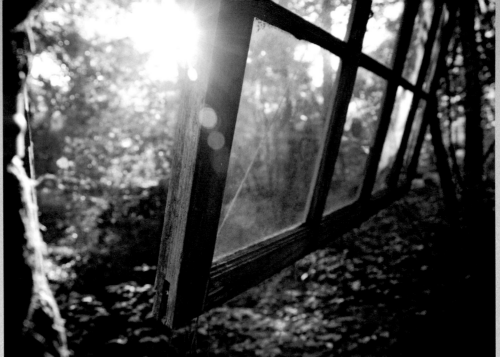

# tree houses

As a renowned environmental advocate, former Executive Director of Greenpeace USA and the Turner Foundation, and currently Executive Director of US Climate Action Network, Peter Bahouth has impeccable green credentials. When he decided to construct a tree house network, his priority was treat the trees with the consideration and veneration they deserve, especially as he planned to execute his project in an indigenous woodland, including Oak, Pine and Tulip Poplar. The largest tree, which hosts the third tree house, is a Southern Shortleaf Pine, over 145 years old and a survivor of the American Civil War.

Peter's objective was 'to return to the feeling of the tree house experience from when we were young and had a board or two in a tree, but little resources to fulfil our imaginations of what a tree house could be'. The three tree houses were planned over six months and built in six weeks. The planning process was quite complex as it involved designing the bridges between the houses and a bed that rolls out on a platform over a creek. For Peter, the trees themselves dictated the process: 'They have a lot to say about what you can and can't do. There's a theory of building where the materials are brought to the site and you allow the site to dictate the structure. That's the best way to go'.

As well as assembling all the materials in advance, including ten 100-year-old windows from a Masonic temple, he had to work out how to construct the tree houses without damaging the trees. His solution was to design a system whereby the large beams at the bottom of the tree houses were not attached directly to the trees but rather via a sliding bracket pinned to them which allowed the trees to move independently of the structures.

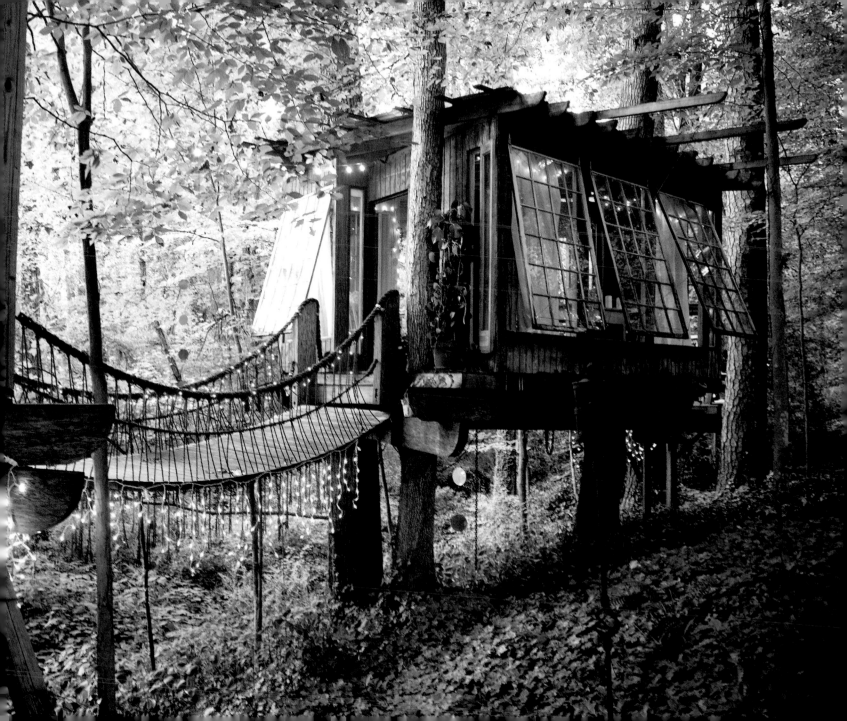

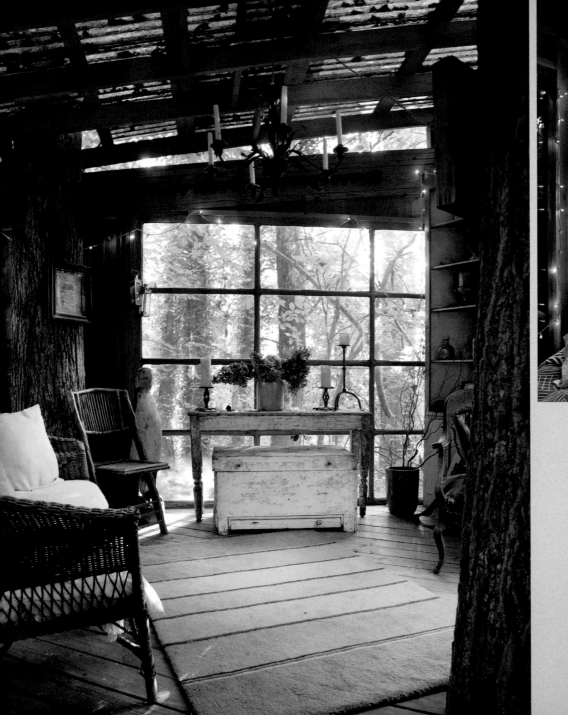
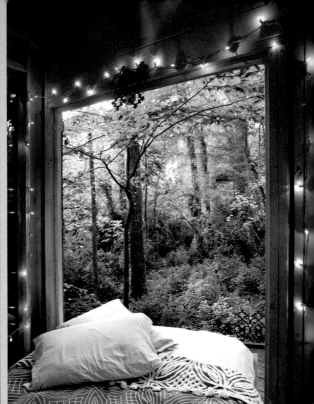

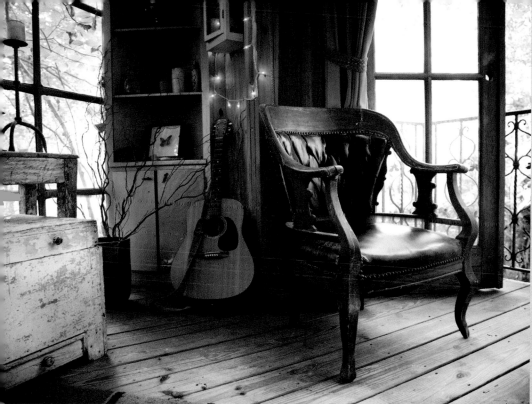

## style notes

The natural materials used in the construction, with their rough, highly textural surfaces, have also been applied to the style of decoration of the tree houses. The rope bridge is made from chunky hemp, which is both functional and decorative. The lighter, knotted vertical rope supports endow it with a sense of movement, while the loose hanging rope ends and the fairy lights have the effect of transporting this structure from the purely functional into the aesthetic sphere.

The wrought iron pieces are carefully placed to create the illusion of a balcony. The rough wooden tables, left deliberately unfinished, the chunky wooden bed frame and the vintage leather button back chair all complement and blend seamlessly into the arboreal space. All the furnishings came from flea markets.

In the heart of the woods, you can't turn your back on the spectacular natural beauty, and the inviting gorgeous bedroom tree house has a welcoming wide, natural opening, so you feel sheltered albeit half inside, half outside. Special care has been taken so as not to overwhelm the treescape and the tree trunks with their strong vertical lines in the living space. None of the furniture, from the spindly turned table legs and the wickerwork chairs to the leather button-backed library chair, seems heavy or unnatural in this extraordinary location. The wrought iron candle sticks with their curved tripod legs allow light to pass right through.

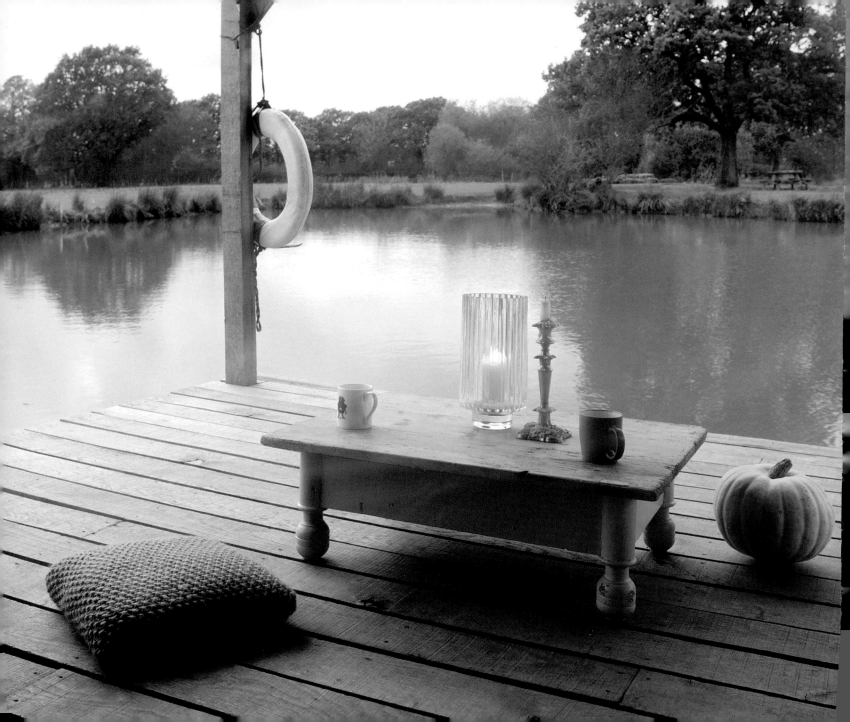

## style notes

The combination of the cosy wooden interior, wood-burning stove and large picture window overlooking the lake helps to give this space a modern twist on traditional country style. The touches of glamour, such as the ornate, glittering chandelier, lift it out of its rustic simplicity, adding a new and surprising dimension. Along with the tall wood-burner chimney, it draws your eyes upwards, enabling you to appreciate the whole space.

Notice the wide and varying widths of the horizontal oak planks that line the walls, creating a substantial and reassuring solidity – having fewer lines between the boards also makes them easier on the eye. This is a subtle yet simple way of creating a cosy, relaxing atmosphere, which works well with floorboards or wall panelling.

The sleeping area, which is reached via a wooden ladder, consists of a pile of vintage feather mattresses, adding to the truly romantic feel of this special place. If you want to create a sense of quiet glamour, try adding a couple of decorative items that can be taken out of their traditional context. What is important is that they are made of luxury materials and include, preferably, a light-source. The crystal chandelier hanging from the wood-lined ceiling, the classic antique silver candlesticks and the glass-ribbed hurricane lamp help to imbue this tiny hideaway with an elegant and romantic atmosphere.

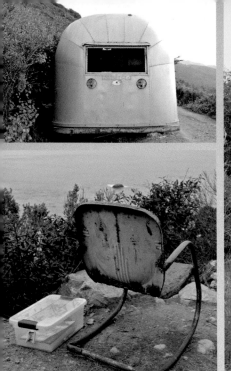

# 'off the grid' vintage trailers

Richard, who owns this steep, rugged and beautiful terrain in Big Sur, perched high above the Pacific Ocean, is passionate about living 'off the grid'. For him, life is all about self-sufficiency and taking and accepting responsibility, and, using solar panels, he generates his own electricity and uses it wisely. He leads a 'life of manifestation' based on his basic belief that everything we need is 'out there and available'. After hitchhiking round the world as a young man, he finally wearied of travel and returned to his roots. He is now the proud owner of a sawmill and 54 acres of unspoilt Californian wilderness, including some venerable 800-year-old redwoods. The land has become his home and his world, and he rents out his small collection of simply furnished and lovingly restored vintage trailers to people who share his enthusiasm for this 'off the grid' lifestyle in a glorious landscape where the night sky is so dark that you can still appreciate its wonders.

Richard says he has an innate sense of spatial awareness – for him, conceiving and designing spaces is easy. The simplicity of the classic trailers and the modern yet elegant bathhouse is ideally suited to this spectacular location. The Airstream and Silverstream trailers are carefully sited on a steep, narrow road that Richard built himself to maximize the benefits of the natural topography, and they all have a panoramic view of the coast. Nothing beats an invigorating outdoor shower or a relaxing soak in the vintage hot tub in the wooden-clad bathhouse overlooking the ocean where you can listen to the singing of the whales on clear, starlit, silent nights.

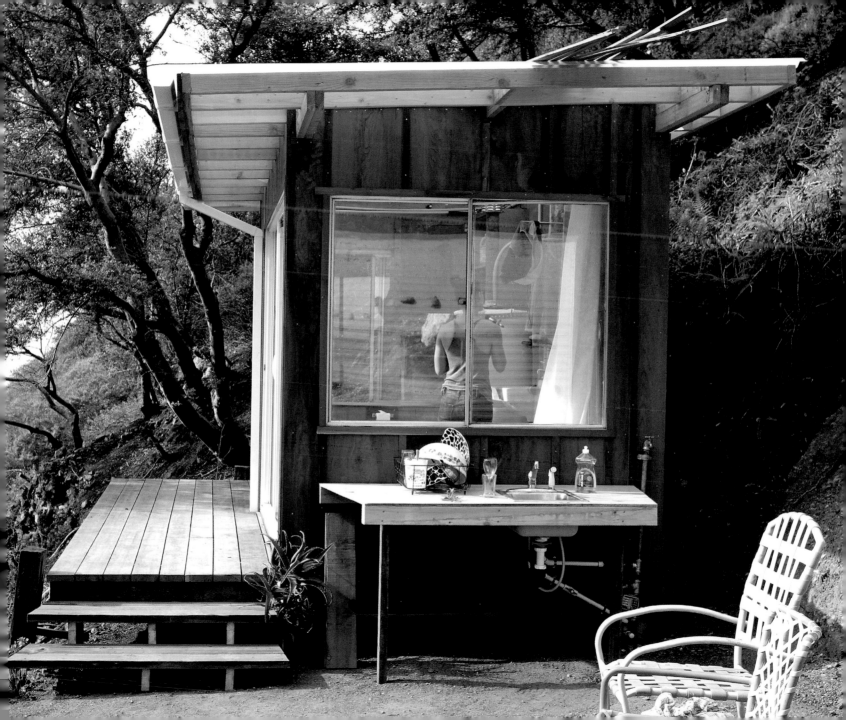

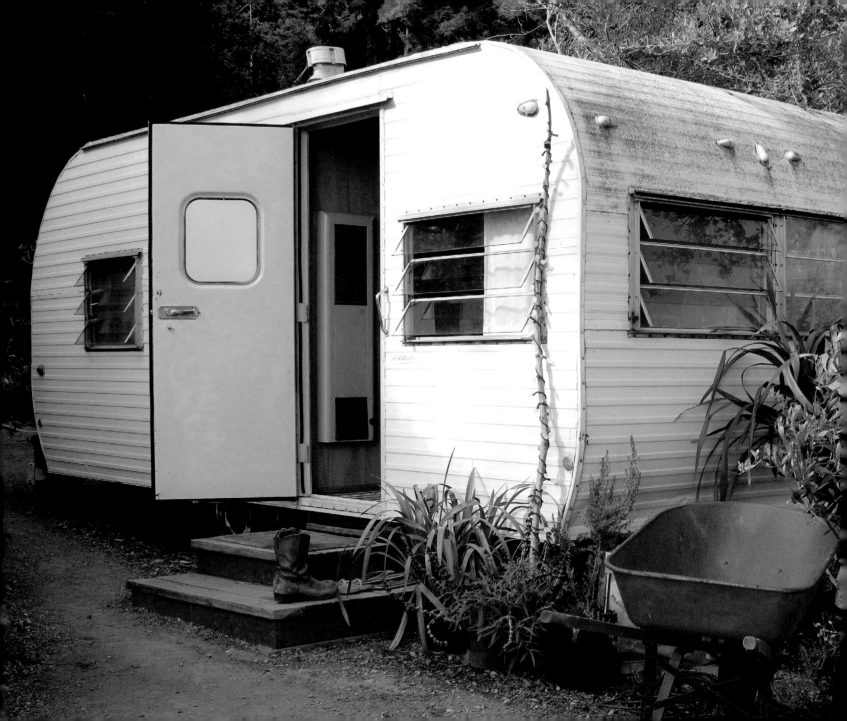

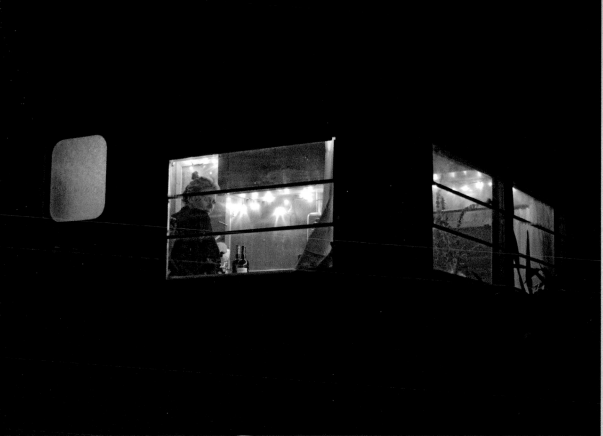

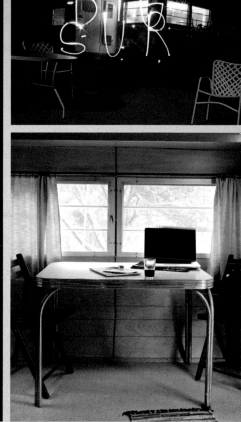

## style notes

The homely trailers are wood-panelled inside and simply furnished with vintage items. Richard is not only an innate homemaker with an eye for detail but he also has a talent for foraging, and nearly everything is second-hand, including the reused stainless steel sink and recycled cast iron bathtub in the bathhouse. The weathered vintage porch chairs are deliberately left outside for guests to enjoy the dramatic panoramic views of the Californian coast – and get maximum mobile phone reception! There is a natural charm to these battered chairs and bulbous trailers. Even their organic shapes have an almost animal-like quality, resembling giant armadillos or woodlice resting incongruously in a natural wilderness.

The design of the bathhouse was kept deliberately simple to prevent it competing with the environment, but inside it's equipped with luxurious amenities. It has a large sloping, south-facing roof area, with big windows on three sides to maximize the views. A small narrow terrace was created to provide a level area for this harmonious building, which is constructed of locally sourced redwood. The rich, natural tone of the timber blends comfortably into the wild landscape. Richard still buys some structural timber but most of the wood comes from fallen ancient redwoods, blown down in winter storms.

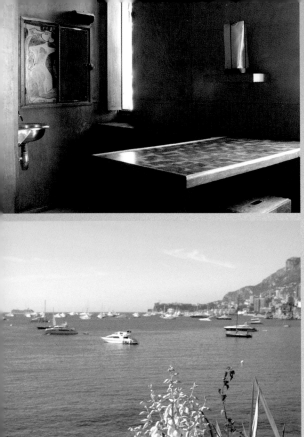
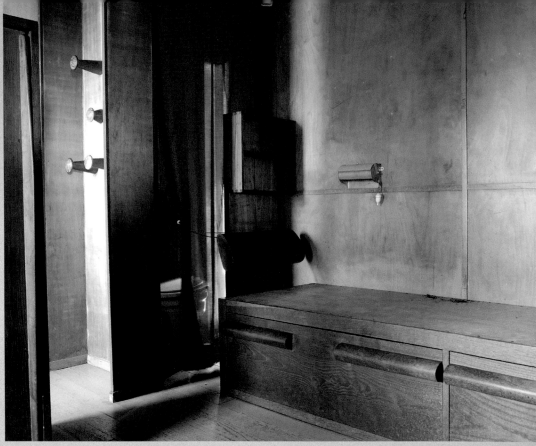

# le petit cabanon

Le Corbusier designed this tiny, one-room summer hideaway at Roquebrune-Cap Martin in the early 1950s. It perches on a narrow rocky pathway, amongst fragrant eucalyptus, agaves and acanthus, on a steep hillside with spectacular panoramic views of the coastline. It took only 45 minutes for the renowned architect to make the original sketches for the cabin, while dining in a neighbouring restaurant. However, what makes it so significant is that it is the only building he ever designed for himself. He said of it: 'I have a little house on the Côte d'Azur. It's extravagant in comfort and kindness. It's for my wife'.

This simple building is only 14m square, but looks are deceptive and its miniscule size, mono-pitched roof and rough pine-log exterior give no immediate clues to the huge architectural legacy in its conception and design. Le Corbusier's approach to his cabin was as considered as for any of his major projects. He believed in making maximum use of available space – 'not a square centimetre wasted'. In this seaside retreat where he enjoyed a simple life, he strove to recreate the modern equivalent of a monastic cell with implicit areas for night and day; nothing was left to chance.

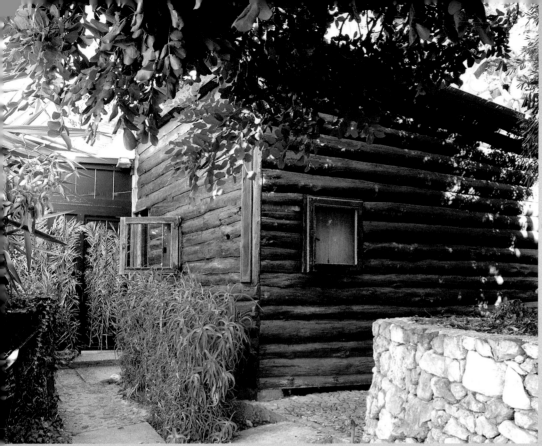

## style notes

This building, with its simple plywood and oak interior, is a wonderful example of how careful planning can make even a small space functional. We feel happy when we're comfortable, and in this cabin the elements that make that happen are left bare for us to see and learn from. Le Corbusier liked to design everything, right down to the fitted furniture, light fittings and even the doorknobs and washbasin. He took his inspiration from many sources – in the case of the metal washbasin, from one he saw on a flight to India. We can learn from these little details and spend some time thinking about what will make a space work for us rather than just slavishly copying something we saw in a fashionable magazine.

Le Corbusier has thought of everything: the wooden mushroom-shaped coat and hat hooks are positioned al the most comfortable height while the furniture and storage areas are built in, their positions fixed in the perfect place. The simple wooden stools have special grooves for lifting and moving them. The bathroom window has bi-fold interior shutters: one decorated by a powerful mural painted by himself – a decorative human touch; the other half a functional mirror, which, when folded back, reflects light into the room.

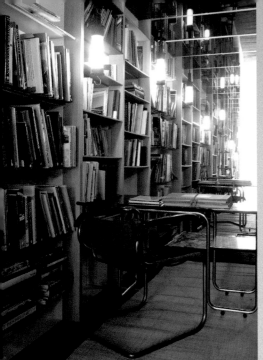

# library containers

This is not only an unlikely setting but also an equally improbable use for two shipping containers. Nestling in an idyllic pastoral landscape in the grounds of an elegant historic house, they were converted specifically to house an extensive collection of books on architecture, antiques, gardening, photography and design. It is an extraordinary scene: at first sight, the modernist lines of the containers appear incongruous but they have been used to great architectural effect, creating a counterpoint to the warm, honey-toned stone building and rolling green parkland with its ancient oaks.

The inspiration for this unique portable library came about when the owner Niall Hobhouse told the architect Cedric Price (now deceased) that he frequently needed to move his book collection. In the seventeenth century, 'bookcases' were lockable book boxes for travelling scholars and it therefore seemed logical to take this one step further by recycling two used shipping containers.

The original concept was to place several containers in a miniature urban grouping, so they could 'talk' to each other. However, although technically movable, this is less easy in practice. A third container may be added at a future date, but set vertically – the optimum way to utilize the available space. Niall works on a range of projects and his library is an interesting, cross-fertilized collection of categories and titles, which continues to expand. It is an inspiring concept: the juxtaposition of thought, design, cabinetry of extraordinary quality and workmanship, and emblematic shipping containers – a unique exercise in high-production values, practically and intellectually.

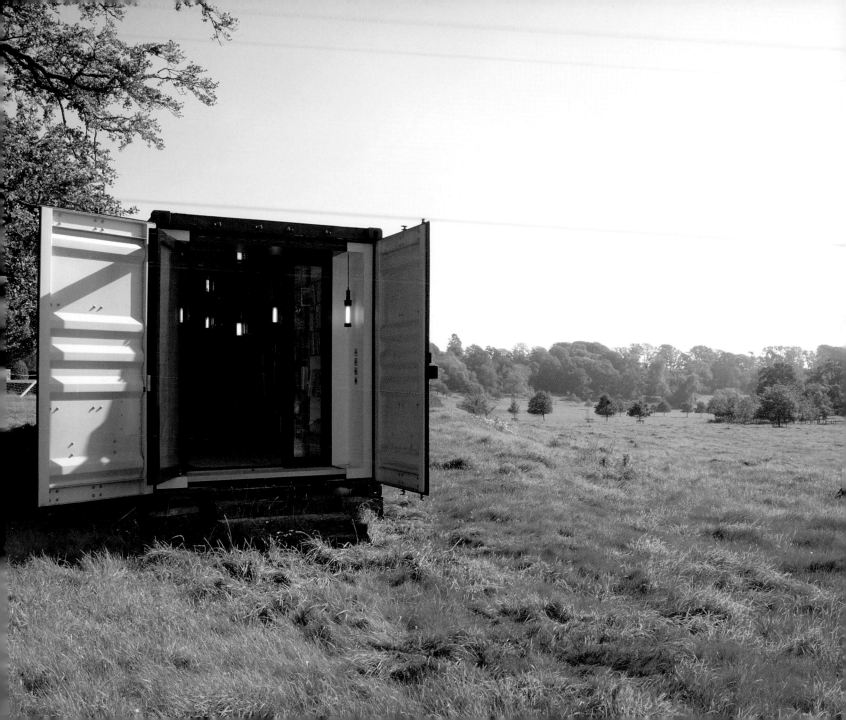

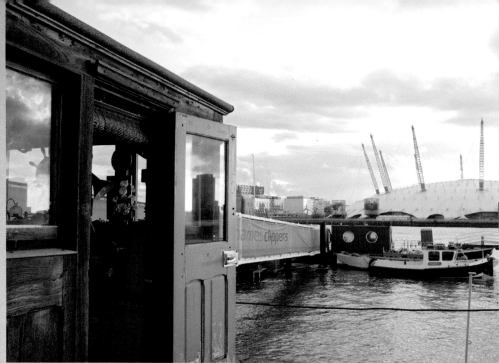

# the wheelhouse

The Wheelhouse sits alone, incongruous and tardis-like, on the waterfront in London's Docklands, almost as though it has landed from another planet in another time. The site at Trinity Buoy Wharf, originally used for maintaining, repairing and storing lightships and navigation buoys, is now a cultural centre for artists and creative industries. This old wooden wheelhouse, now transformed into an artist's studio, symbolizes the area's shipping heritage. Donated by the Museum of London, little is known of its history – it's a piece of flotsam and jetsam with a mysterious past, which influences the work of resident artist Julie Newman. It is amazing that it has survived at all.

The weathered teak building is miniscule, only 2.1 x 1.95m, but inside it's light and airy with windows on all four sides. These were essential in its earlier incarnation when it housed a ship's wheel; at sea, they provided good all-round visibility and protection from the wind, rain and spray. Even in its present position on the wharf, when you enter this creative space you feel as though you are a part of the river and the changing landscape right in front of you. Julie, who comes here to sit and think quietly about potential projects, develop ideas and research resources, feels 'gifted' and 'freed by the river'.

What started as an argument about disabled access ended with Julie applying to use this tiny space; she can park nearby and, aided by her sticks, can walk the few steps to the studio. She thinks that people are drawn to this intriguing little building by its 'sense of adventure', and passers-by often pop their heads around the door for a chat.

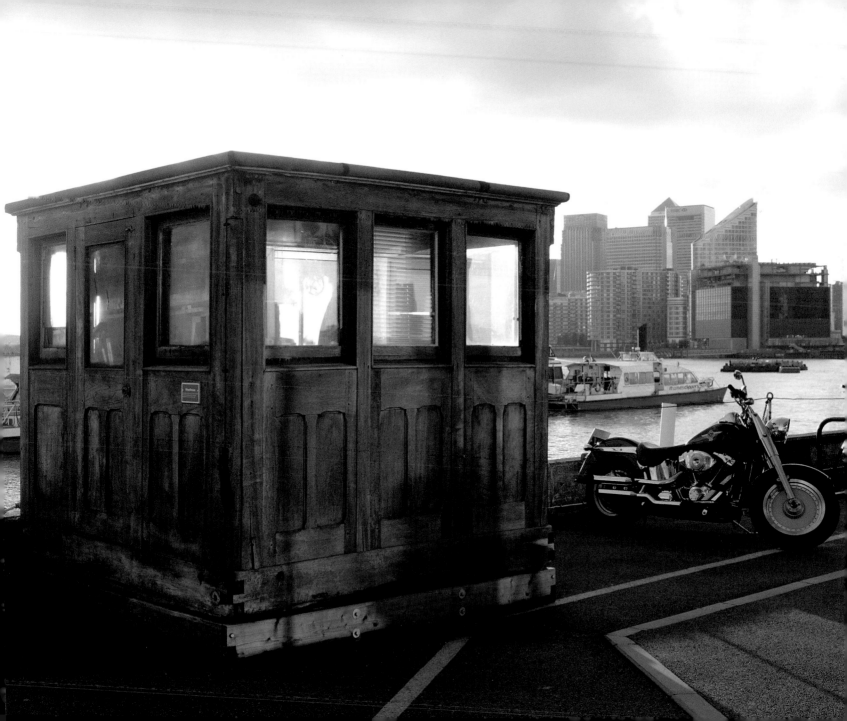

# norwegian cabin

Hanne and Per, the owners of this remote Norwegian cabin perched on the side of a mountain, wanted a cosy winter retreat where their family could spend time together with 'no escape' for the children. It's a three-hour drive from their home, and every Thursday or Friday evening they load their children and bags into the car and drive intrepidly into the night. When they arrive, their first job is to light the fire and open a bottle of red wine. They love 'just sitting on the day-bed, enjoying the quietness, the smell and the light from the fireplace, and the view of the snow'.

Their initial search for a suitable old timber house that was ripe for renovation was fruitless, so they ended up buying a plot of land and building their own cabin as it was the only way in which they could achieve the interior configuration they wanted. Hanne had a clear vision of what they were looking for and, with her inspiration, Per drew up the plans, right down to the last detail. The exterior of the cabin is similar to some of the older properties in the area, but it has been built using modern construction methods and inside it is radically different. The bedrooms are on the lower level whereas the large open-plan living, kitchen and dining areas are upstairs. This living space is fully integrated and leads straight out onto the ski slopes.

Hanne and Per use the cabin almost every weekend during the skiing season from December through to April, spending longer periods there over Christmas and Easter. It has been so beneficial for them: 'We ski, eat, play cards and watch films together. Usually it's just us but sometimes our friends and their children come, too'.

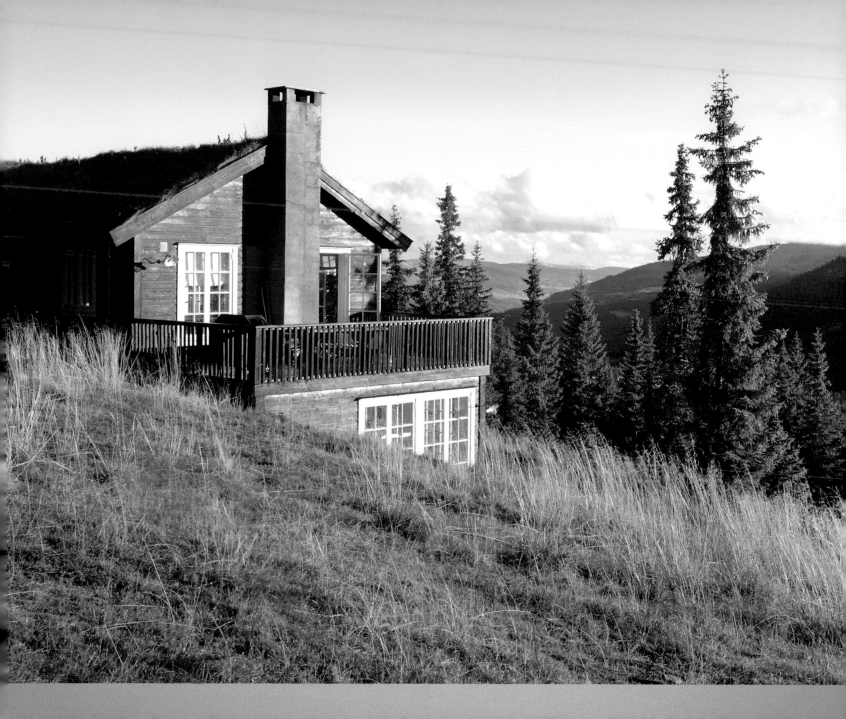

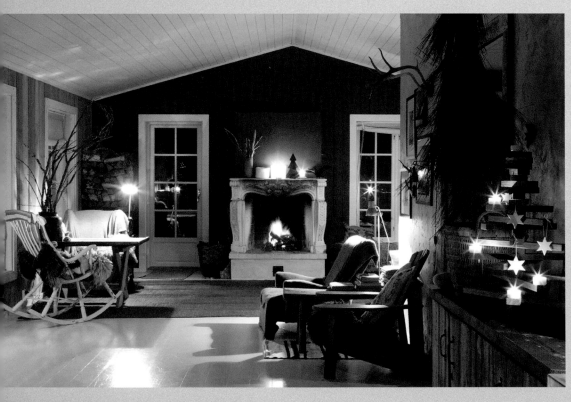
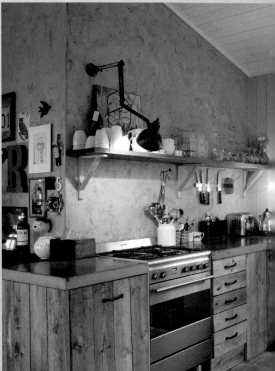

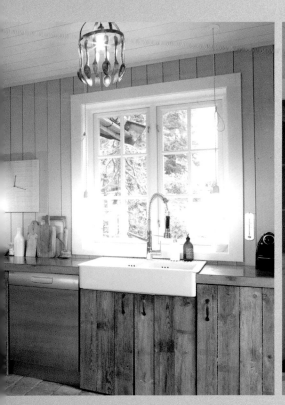

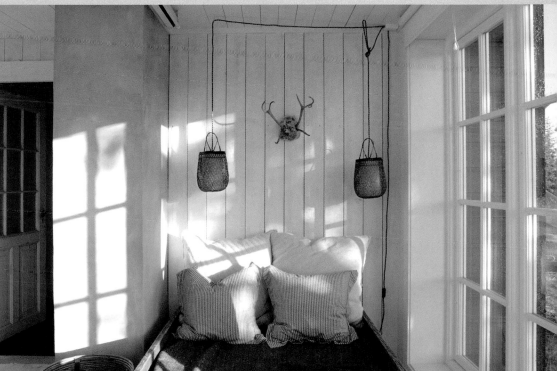

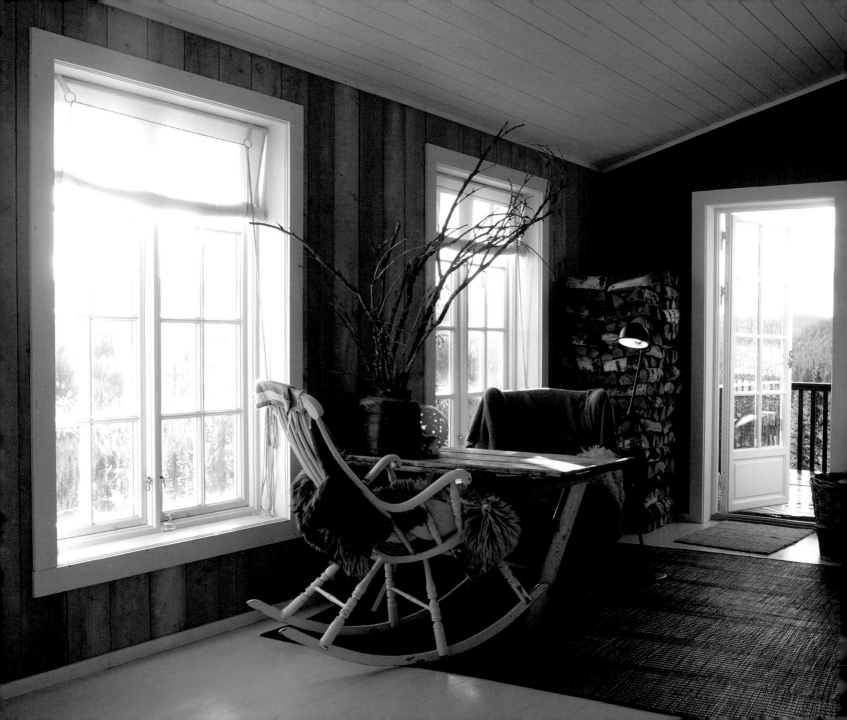

## style notes

Hanne co-owns Bolina, a renowned lifestyle and interiors shop in Oslo, and she has a strongly developed instinctive feel for design. When she and Per were planning the interior of the cabin they decided what they liked most about their main home, another wooden house albeit much older, was its 'soul'. Their challenge was how to create this elusive quality in a new-build property, and the solution they hit on was through the intensive use of vintage items and materials. They didn't want it to look 'too perfect' nor 'too luxurious' and opted for some surprising combinations. They placed an ad in their local newspaper, looking to 'buy old stuff and materials' and spent the next two weekends driving around the neighbourhood buying a multitude of interesting items for their new cabin, including 14 interior doors, each one a different shape, colour and size!

The surfaces throughout are all highly textural, reflecting the outside environment, and recognizing that it's essential to keep your house in context when deciding how to decorate the interior. The living area is panelled with vertical planks of vintage wood, while a neat pile of logs adds to the theme of naturally distressed timber. This is carried through to the kitchen cupboards, which are regular Ikea units but with wooden planks from an old barn mounted on the door surfaces. Even the table is really chunky with an ultra-thick top and trestle-style legs. The kitchen walls are concrete as is the work surface, creating a cool, slick counterpoint to the rough texture of the wood.

The cold Nordic light works best with neutral colours: strong greys are used for the walls, the floor is painted a simple white, and the remaining wood is natural, bleached and unfinished. This pure palette is used throughout the cabin, including the plastered kitchen with its steel details. Even the fabrics have a natural finish and texture: linens with a chunky slub weave, ticking, knitted textiles, felt and goatskin.

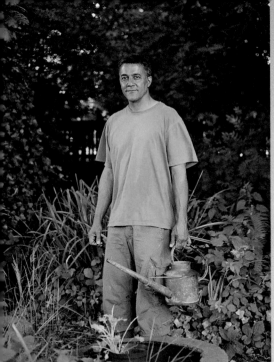

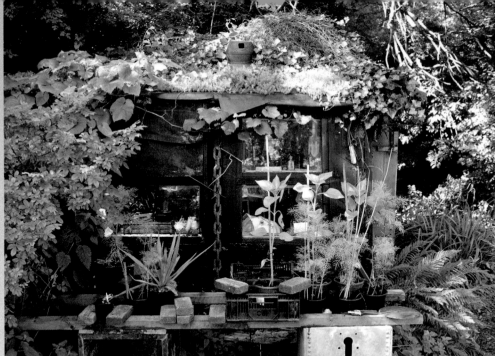

# allotment sheds

The garden designer Cleve West is the winner of three Gold Medals at the Chelsea Flower Show, so you could be forgiven for thinking that his would be a perfectly neat and ordered world. However, this couldn't be further from the truth, as demonstrated by his ramshackle allotment and three garden sheds. This is a man who thrives on imperfection and improvisation and his work reveals that he is happiest working alongside nature, often planting in naturalistic forms as if the seeds had been dispersed by the wind. He approaches his sheds in the same spirit. He starts off with the ghost of an idea and what happens next is governed by whatever materials are available.

Cleve's allotment is the inspiration for his work, together with a strong sense of family and community. All happily collide here on this blessed plot and ferment to become a living, growing and creative space. Vegetables and flowers co-exist happily alongside each other in natural harmony. His best in show garden at Chelsea featured parsnips, gone to seed and forming mysterious seed heads. They confounded onlookers who could not identify these delicate-looking plants, which had been nurtured on the allotment.

Cleve's initial allotment has grown steadily over the years, its tentacles spreading out over four adjacent plots. He says that he could not survive without a shed and he is now building his fourth. Sited beside a Royal Park on the periphery of London, the municipal allotments are entered through a nondescript wooden doorway in the original narrow redbrick walls. On a hot summer's day with a herd of red stags cooling off in the nearby slow-flowing river, this is a green oasis amongst the hustle and bustle of city life.

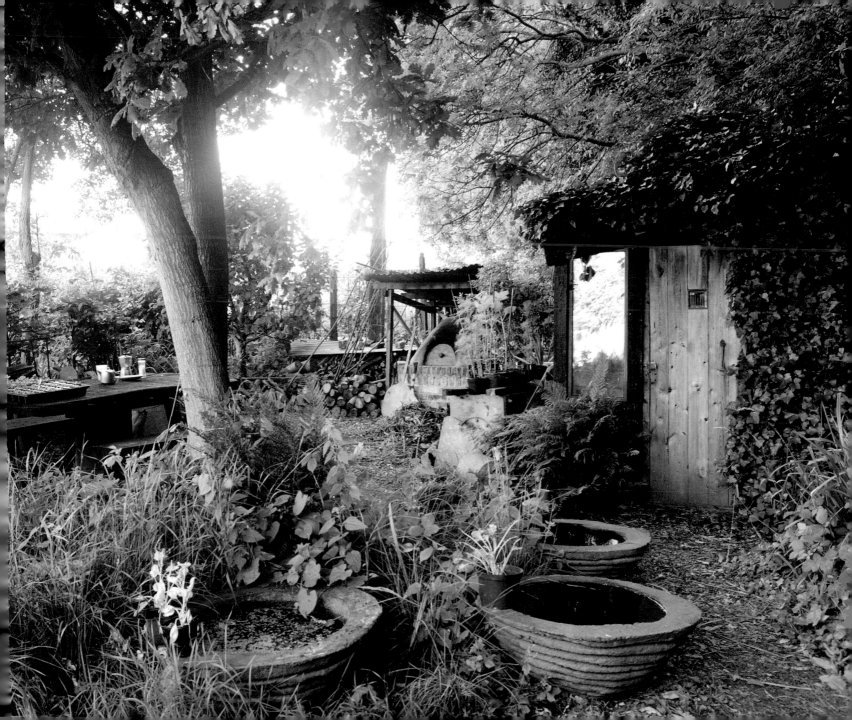

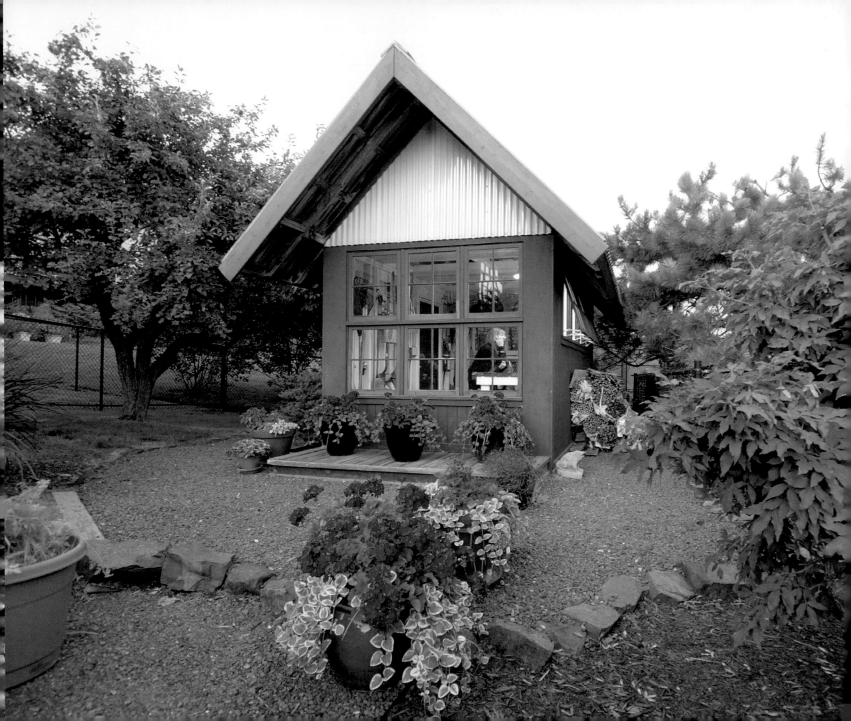

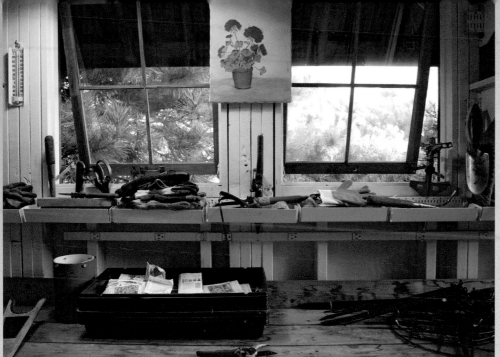

# potting shed

Patrick and Robyn, the owners of this unique potting shed, are keen gardeners but the extreme climate of Duluth, Minnesota, with its exceptionally cold winters, imposes limitations on their gardening ambitions. Constructed on a hillside overlooking Lake Superior, this shed has amazing panoramic views but is exposed to bitterly cold winds and sub-zero temperatures. The growing season is exceptionally short as frost is still on the ground at the end of May, and by early September the chill winds return. It's not surprising that Patrick and Robyn decided they needed somewhere for growing plants from seed as well as storing tender pot plants, garden tools and equipment.

After investigating their local home improvement and hardware stores in search of something exciting and different, they decided to commission their own shed and gave Silver Cocoon, a local firm of architects, a pure and simple brief: to create a shed that would meet their gardening needs, blend in with the environment, and be a great place to spend time relaxing. The result was cosy but not confining and an inspiring example of the 'sensible design' that these enterprising young architects strive to create.

The potting shed has enabled Patrick and Robyn to transform their garden into a glorious natural abundance of annuals, perennials and tender-leaf vegetables. They have created a private outdoor space where they can enjoy simple pleasures. They have realized that mixing the practical and aesthetic, and finding an outlet that is significantly different from their day jobs, are necessary to achieving a desirable balance in life.

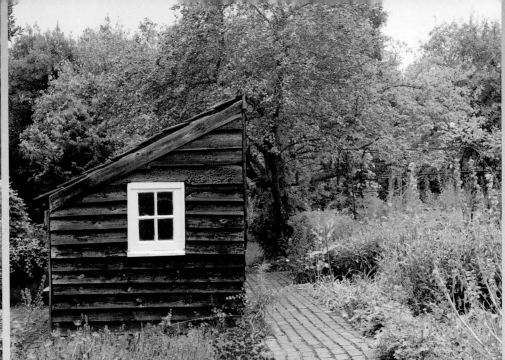

# william morris's garden shed

The founder of the Arts and Crafts Movement, William Morris was one of the most influential designers and original thinkers of the nineteenth century. Inspired by his observations of the natural world, he lived at Red House from 1860 to 1865. His vision and natural instincts were to commission a unique house, with all its furniture and decorative details designed by him or in collaboration with the pre-Raphaelite Edward Burne-Jones.

His philosophical and design influences were medieval European monasteries and cathedrals, along with the writings of Chaucer. Sited on the old Pilgrims' Way between London and Canterbury, the Red House was the perfect geographical fit for his ideas. Instead of focusing on the present, he sought his inspiration in the past and the simpler crafts-based way of life that had existed before the advent of the Industrial Revolution.

Morris loved nature and believed that a house and garden should be treated as a whole, with the garden designed 'to clothe the house'. The natural environment inspired many of his most famous designs, and stylized fruit, birds, floral and leaf designs feature strongly in many of his wallpapers and fabrics, which are still popular today.

This small garden shed, extended over the years, sits between the vegetable garden and more formal gardens. Whether it is the original structure is not proven, but a shed was marked on this site in the original plans. This was an intensely creative period in Morris's life when he experimented with new wallpaper and furniture designs, stained glass, painting and even poetry. He was particularly fascinated by the intricate patterns of the plants growing in the garden and created his first wallpaper, 'Trellis', here in 1862.

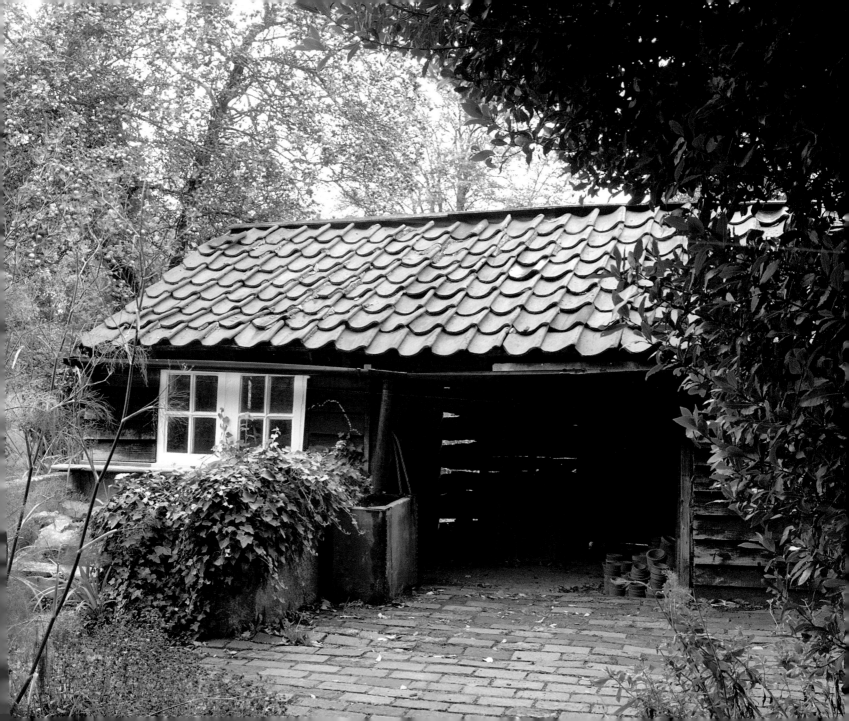

# writers

In this section, we feature three giants of the literary world who all worked in similar buildings: small, self-contained writing huts tucked away from the bustle of their main house. What makes this even more interesting is that their houses were all substantial in size with plenty of rooms and yet they chose to write instead in simple wooden sheds.

Dylan Thomas's shed was a former garage, albeit with some spectacular panoramic views of the estuary at Laugharne. Virginia Woolf's writing hut also had a peaceful outlook, across the gentle water meadows of the River Ouse to the South Downs. Both these writers were influenced by their location and found the aspect inspiring. In contrast, George Bernard Shaw's writing shed is tucked away and surrounded by trees, although he installed a revolutionary mechanism in order to rotate it towards the sun as it moved across the sky throughout the day.

All three sheds are furnished in a simple, practical fashion and any decoration is minimal and limited to meaningful and inspiring images or scraps of their writing pinned to the wall. Indeed, Dylan Thomas 'would leave his there until they had become totally furled up' and his wife Caitlin would then replace them. Old photographs of his shed illustrate just how messy it was, with screwed-up pieces of paper strewn around, while George Bernard Shaw's writing hut is more cluttered in the original images than it currently looks. There is very little pictorial evidence of how Virginia Woolf kept the interior of her writing room, and the National Trust have done their best to recreate it, using key items, such as her lamp and distinctive blue writing paper, to furnish the space.

The common thread uniting these three totally different writers was their need to develop a regular routine and pattern of work away from their domestic lives. By retiring to their work huts, they separated themselves from everyday life and found the inspiration and privacy that were so important for their literary output.

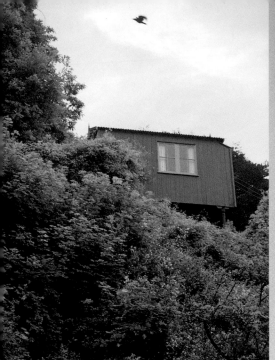

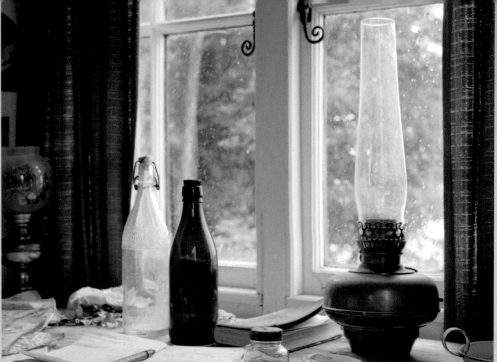

# dylan thomas's work shed

Perched precariously on iron stilts on the edge of a cliff in Laugharne, South Wales, this shed was formerly a garage, built in the 1920s. When it was purchased by Margaret Taylor, Dylan Thomas's patron, in 1949, some fixtures and fittings were negotiated, including an old anthracite stove, a large bookcase and two tables. Dylan thanked Margaret in a letter: 'All I write in this water and tree room on the cliff, every word will be thanks to you'.

The shed fired his imagination, and he also referred to it as his 'wordsplashed hut' or, more famously, in Poem on his Birthday as the 'house on stilts high among the beaks and palavers of birds'. Like most writers, he developed his own special daily routine: pottering about in the mornings, a lunchtime drink at nearby Brown's Hotel and the afternoons between 2pm and 7pm working in his 'study, atelier, or bard's bothy'. Inside this little hut, he produced some of his finest work, but inevitably, due to its exposed location on this windy, rain-lashed cliff, the shed fell into disrepair and it was dismantled in 2002, piece by piece, to be renovated for the fiftieth anniversary of his death in 1953. Now fully restored and Grade 1 listed, the interior has been well researched to sympathetically recreate what it would have looked like in the 1950s when Dylan Thomas worked here.

It's the poetic nature of this location that is so bewitching – the sense of isolation and physical separateness from everyday life. The only sounds you can hear in this remote place are the howling winds, the crashing waves and the wheeling seagulls. You feel like an outsider, an observer of a timeless landscape in which the changing weather, the tides, the vast mud flats and the shrieks of the birds form the rhythm to your thoughts.

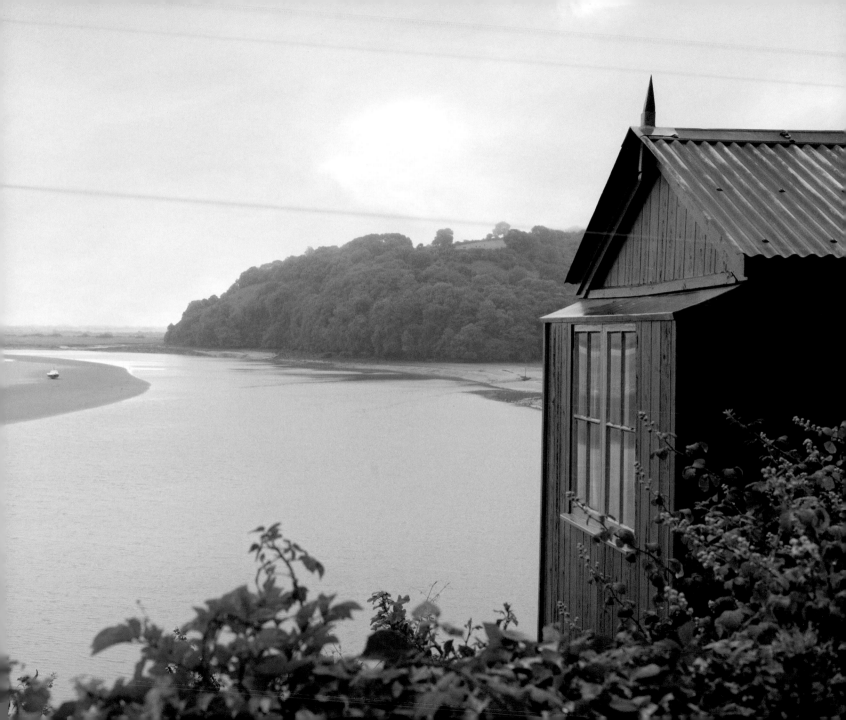

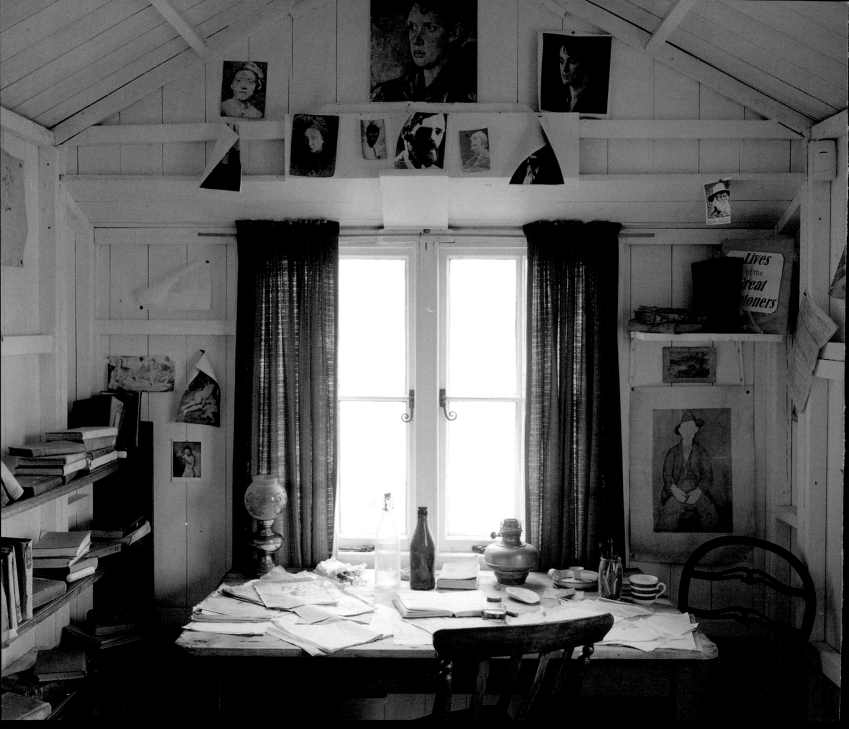

## style notes

From the exterior this simple timber structure still looks like a traditional domestic garage, but, ironically, this humble building has played an important role in our cultural and literary heritage, making it a powerfully evocative space. The simple interior is not about design or style; it's homely, down-to-earth and comfortable without any hint of ostentation. It's an organized mess where Dylan had all the things he used regularly and valued close at hand – his pens and pencils are stuffed into a simple jam jar, the rubbish bin is full and overflowing, and the floor around his desk is littered with scrunched-up paper from the hundreds of drafts he wrote and rejected before completing a poem. The walls are lined with inspiring photographs and old magazine cuttings of the poets and artists he admired – Byron, Walt Whitman, William Blake and Modigliani – as well as rhyming word lists. The table is piled high with untidy, haphazard piles of work in progress and countless drafts of his poems.

His desk faces the same spectacular view across the estuary and the bay, where he used to watch his wife Caitlin and children catching flat fish in the wet sand at low tide. The window is framed by a pair of homespun, warm mustardy brown curtains.

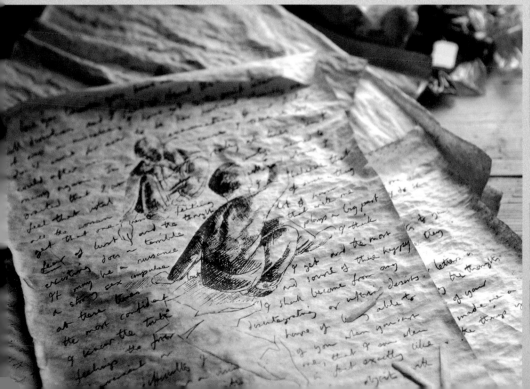

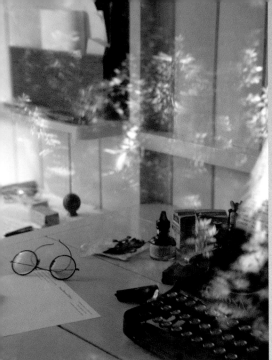

# george bernard shaw's writing hut

Shaw was a true polymath – a multi-talented writer, playwright, political activist, co-founder of the London School of Economics and pioneer of early photography. He was awarded the Nobel prize for literature in 1925, and a best screenplay Oscar for *Pygmalion* in 1938. With his wife Charlotte, he owned the large 10-bedroomed rectory at Ayot St Lawrence from 1906 until his death in 1950. They both liked the peace and space of the surrounding countryside and spent long weekends there.

Shaw's little revolving writing hut, which was originally Charlotte's summerhouse, is tucked away at the bottom of the garden, hidden by a row of tall trees beside a grassy path. He specially commissioned this eccentric hut with its revolving mechanism, so that he could follow the direction of the sun as the day progressed. The structure rotates on a metal track set on a wheeled base by means of a manually turned handle. It was here that he is reputed to have written some of his best plays, including *Man and Superman*, *Major Barbara* and *Pygmalion*.

Existing photographs show a nattily dressed Shaw working in the wooden hut, an electric fire at his feet, his typewriter sitting on a folded tasselled blanket in the style of a table cloth, and the day bed piled high with boxes, cases and paperwork – this was his own private domain where he could hide away from people and work without any interruptions. There is even an amazing piece of film footage of him on his ninetieth birthday, walking jauntily in the garden and flourishing a cane.

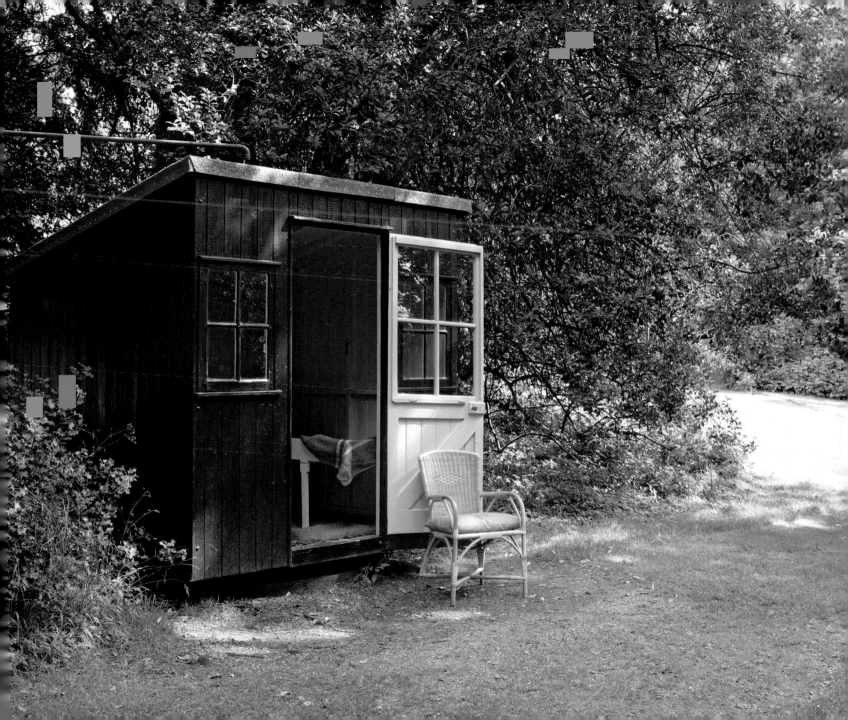

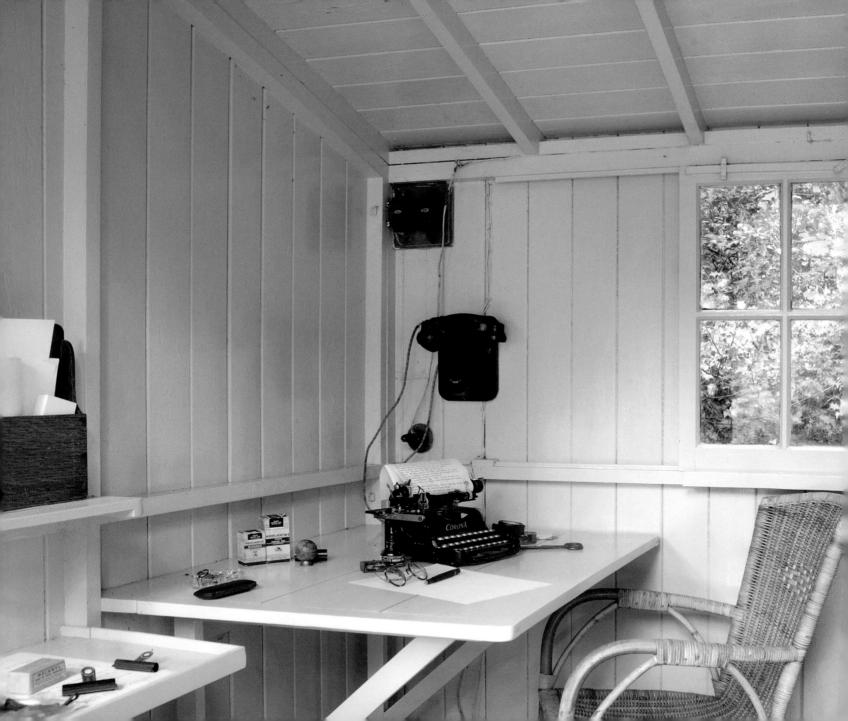

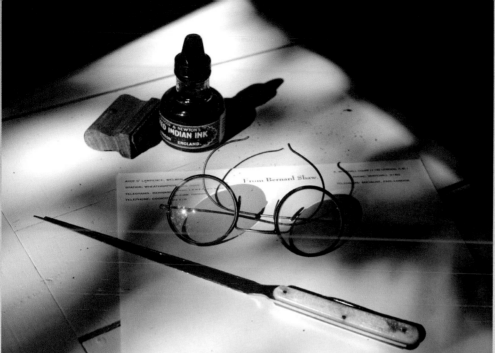

## style notes

This small square hut is tucked away, out of sight of the house at Shaw's Corner in Hertfordshire. What is particularly striking is its simplicity, which is in sharp contrast with the much grander main house. It is a utilitarian space, well equipped with the basic necessities, but with a few surprises, too. The small rear window opens by means of a clever sliding mechanism, and the telephone and piped-in electricity were incredibly modern and innovative in Shaw's time. He was among the first people to recognize the usefulness of this new technology and had even installed a generator in his house.

The interior of the writing hut is unassuming and functional: the walls are painted in a neutral eau de nil colour and the floor covering is a modest linoleum. It is simply furnished, with a writing desk, a telephone, a small side table and a fold-down day bed. It acts as a blank canvas, a homely space, where the great writer and playwright could work without any distractions. In this tranquil setting, where the wood pigeons coo seductively in the trees outside, Shaw found the peace and quiet he needed to get away from humdrum domesticity and think clearly.

This is a deceptively clever small space; as well as turning towards the sun, the writing hut feels reminiscent of a sanatorium – radiant with light and filled with healthy fresh air. Moreover, the space itself is well designed. The desk is hinged at the back, so it folds flat, and the legs do not encroach into the space but are more like large brackets off the back wall. Similarly, the day bed can fold flat against the wall if additional space is needed.

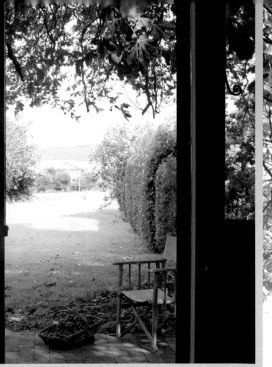

# virginia woolf's writing lodge

Virginia and her husband Leonard bought Monk's House in Rodmell, East Sussex, in the summer of 1919 as a weekend and holiday retreat. The house needed substantial renovation work but Virginia liked the large garden and its open aspects over the flood plains of the River Ouse across to the South Downs in the distance.

This small weather-boarded writing lodge with its wooden shingle roof and symmetrical brick terrace was not built until 1934 to replace her original writing room inside the house. It is tucked away in a leafy corner of the garden beside a low flint wall and next to the neighbouring church. Virginia was excited about the prospect of having her own private space where she could write without any interruptions: 'There will be open doors in front, and a view right over to Caburn. I think I shall sleep there on summer nights'.

Her days followed a regular work pattern: she kept a notebook and pencil by her bed and after breakfast she would have a bath and read her work aloud before going down the garden to her shed to work for three hours.

The writing lodge was a peaceful, comfortable place, and there are photographs and paintings of the couple with their literary and academic friends, including E.M. Forster, John Maynard Keynes and T.S. Eliot, sitting outside the shed, talking or playing chess. They created a pleasurable life here together, which Virginia later described as 'after the fashion of a mongrel who wins your heart'.

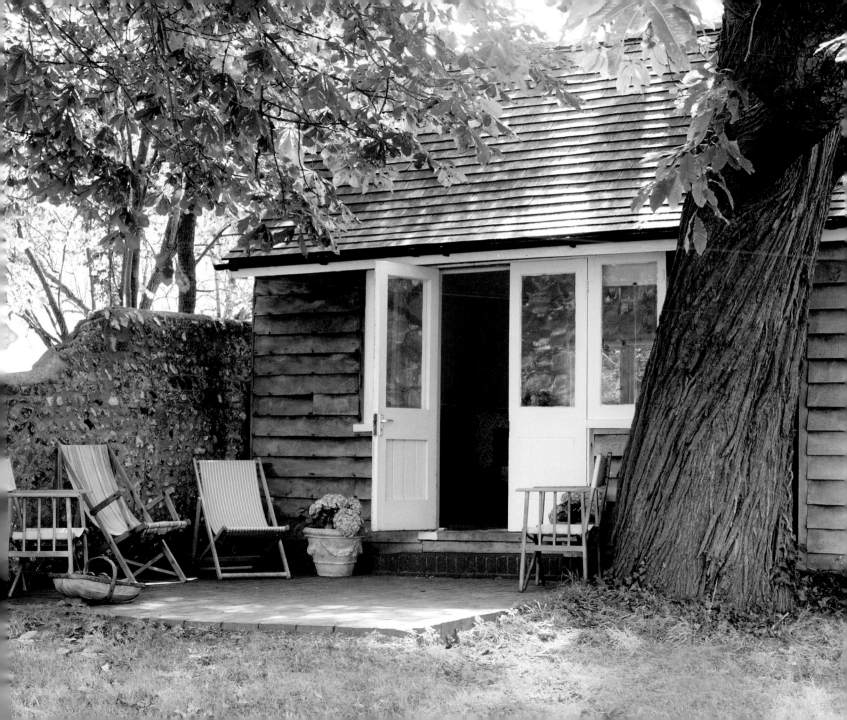

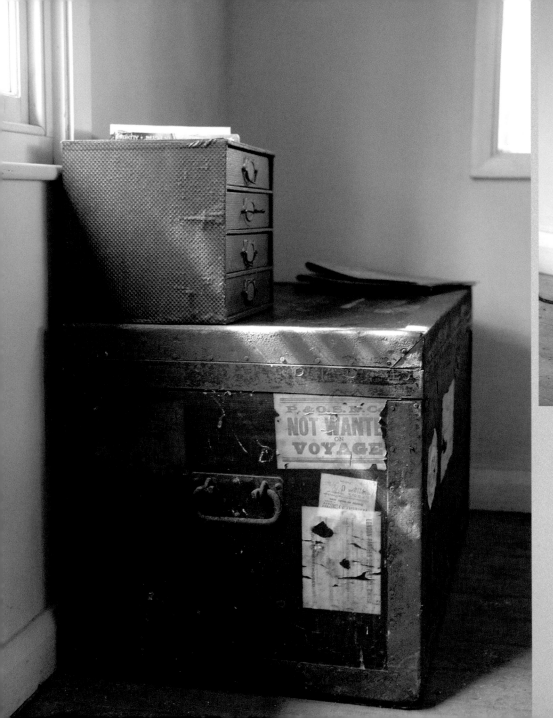

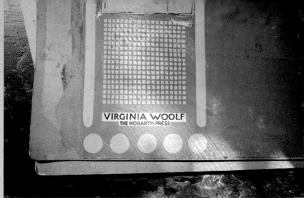

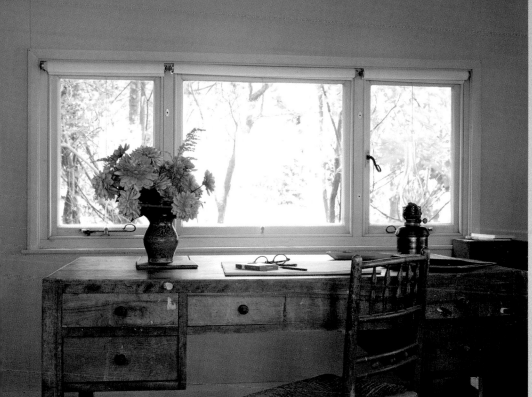

## style notes

Even today, 70 years after Virginia's death, this writing room has retained an atmosphere of peace and concentration. It is a light, airy space, simply furnished with some original pieces and the desk at which she wrote. The shed is surrounded by the garden on three sides and through the window on the back wall you can see the apple orchard.

We don't know exactly how the room was originally furnished but certain key artefacts are still here. Virginia's round tortoiseshell glasses are on the desk, along with the lamp she used to write by, her blue writing paper and a packet of the brand of cigars she liked to smoke. Family mementos are all around: an old monogrammed trunk belonging to Leonard, festooned with labels from exotic destinations, and a set of files in which she kept her notes, decorated with elegant hand-drawn circles and geometric cross-hatching. This distinctive pattern is typical of the Omega Workshops and the famous decorative style of Charleston where her sister Vanessa Bell lived. There are old idyllic photographs of Virginia and her friends sitting in front of the shed, with its doors thrown wide open, in an assortment of directors' deckchairs.

This writing shed is not only an important part of our literary heritage but it is also a lesson in finding a special place and decorating it with meaningful objects. Virginia believed that in order to write, a woman must have 'a room with a lock on the door'. In her little wooden shed, she found the privacy and solitude she craved.

# workspaces

Shedworking is becoming increasingly popular as more people embrace the lifestyle of working for themselves and start up fledgling businesses. Working in our own individual space has become a cherished dream for many of us, whether it's a shed at the bottom of the garden or an ingeniously recycled structure in a creative community. In this section, we feature some spectacular re-purposed items that are now used as workspaces, from disused shipping containers to redundant London Underground carriages.

Two of these examples are geared towards people with creative businesses who want to rent a workspace, but small manufacturing industries can benefit, too, from the new trend for shedworking. Alexei Gaylard started his career in high-tech global mass shoe production but has now returned to his roots producing ethical products in his self-designed eco–shed with its planted roof and hempcrete walls, which is ecologically sound and representative of the brand values of the work he carries out there. Other working sheds that have been designed for purpose include the stylish 1930s Modern Architects office at Mottistone Manor and the strikingly contemporary Hackney Shed, nominated for a RIBA small projects award.

The simple off-the-shelf garden sheds featured in Junkaholique are inspirational and a lesson in how to use ready-made, otherwise everyday, buildings in a completely new and refreshing way. Simply painted and equipped with carefully selected decorative and functional items, they are conveniently located in their owner's back garden, creating an inexpensive, idyllic and productive workspace.

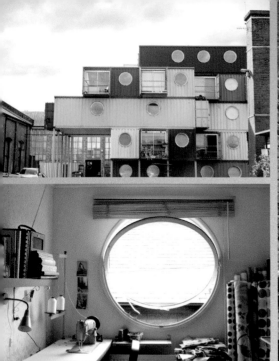

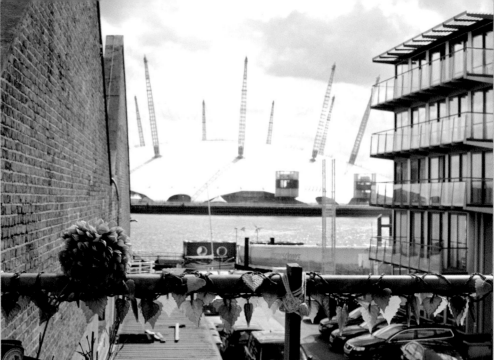

# container city

Matt and Sophia were inspired to transform three unprepossessing sea shipping containers into a design studio for their successful business, selling pvc coated bags. The modular containers are stylish and structurally strong, providing a green and affordable alternative solution to finding studio space in a crowded urban metropolis.

The rapid organic growth of their business highlighted the urgent need to source a suitable studio. Sales were doubling each week but Sophia was still making the bags on an Ikea table in her bedroom at home while holding down two day jobs. This unique riverside studio development, with its collection of brightly painted, recycled shipping containers, was established to provide scarce studio space for the artistic community. Matt and Sophia were attracted by the space and luminosity and were right to trust their initial instincts – the containers provide a light working space all the year round.

Matt and Sophia's studio space is made from three recycled containers, linked together with their internal walls removed. The original double-width loading doors now function as side walls to the pretty balcony with its amazing views across the Thames towards Greenwich. Porthole-shaped windows have been cut into the container sides as a reminder of their shipping heritage. Five storeys high, the containers were designed for stackability and practical, functional use.

Ultimately, it is the river that affects and defines the space, not just in terms of its reflected light but also as an omniscient presence. At certain times of day, this strongly tidal section becomes completely and eerily still – like glass.

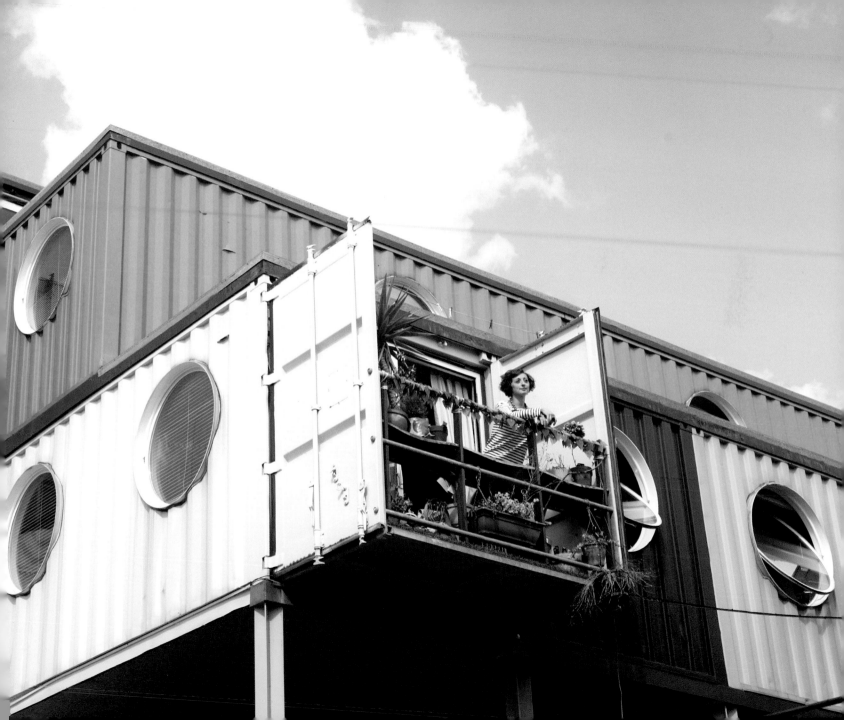

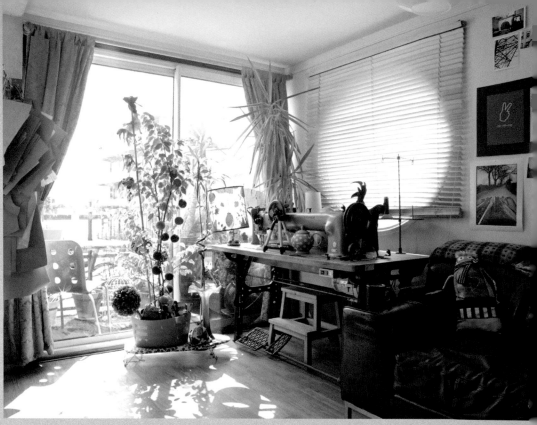

## style notes

In their business ethos, Matt and Sophia's characteristic style is to let the fabrics speak for themselves and not to over-complicate things. Their decoration of the studio reflects this trend with its bright colour, patterns, and Scandinavian and Japanese-influenced style. They save and collect anything that catches their eye and takes their fancy, such as remnants of vintage wallpaper, which are used to cover small areas of the walls. An array of artefacts, found along the way, are lovingly kept and given a home here. Indeed, the haphazard arrangement and impromptu still life collections are all important sources of inspiration for their work, now or in the future.

Here their fabric is stored, ready to be cut, pattern pieces hang on the walls, and the big central cutting table is the focal point of the working space. Recycling is embraced, and most of the machines have been purchased second-hand or are hand-me-downs. However, this is not only a practical working environment but also a comfortable space that belies the volume of output of the bags produced

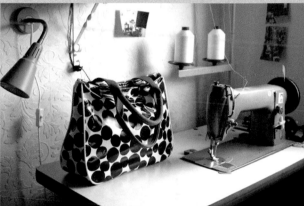

here. Over time, the studio has evolved into a home from home for Sophia and Matt, and the addition of a leather sofa has helped to create a relaxing lounge-like area. Its development was natural and unplanned and it has become a 'real reflection of them' and a workspace that feels genuinely good to be in.

Creating a separate environment from your home can allow you to experiment with different decorative schemes – and it doesn't really matter if everything is coordinated or not. However, surprisingly, what often happens is that if you consistently select items and styles you truly love, or that interest you, and you are true to your own tastes and preferences, unexpected combinations and ideas emerge. There is a certain freedom from constraint here that is creative in itself.

It's fun to go with the flow of your instincts: witness the mixture of wallpapers, the pot plant that becomes an all-year-round Christmas tree, decorated with multi-coloured fairy lights, and the fake flowers. These complement the circular cut outs on the back of the green plastic balcony chair and the porthole window – happenstance is a wonderful thing!

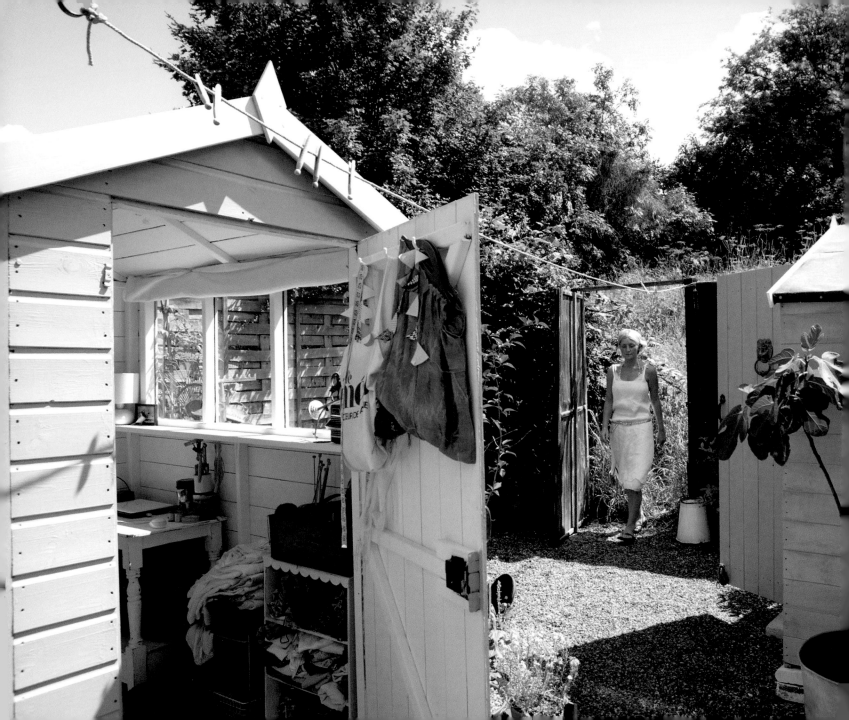

# junkaholique

Living in the centre of a big city inevitably brings space constraints, but working from home places further demands on your living space. This industrious young couple solved the problem with not just one but two garden sheds. Artemis and Naos are the proud proprietors of several businesses, including: Rust, an artisan jewellery company with a shop in Japan; and Bucket Tree, an online vintage clothing and homewares store. Artemis also writes the successful and much-acclaimed lifestyle 'junkaholique' blog.

Artemis had the original brainwave of constructing a shed, and Naos liked it so much that he got one too, to use as a workroom for repairing and restoring the leatherwear they sell online. The artful gravelled garden takes you by surprise as it opens up via a rickety back gate onto an unexpected area of meadow with an idyllic view, endowing it with a sense of space and freedom. Artemis says: 'When you live with someone you have to share the decisions but having the shed means that I am free to do my own thing'.

Both traditional unexceptional garden sheds are painted an orderly, unobtrusive shade of 'Antique Grey' inside and out – even the floorboards – and they have taken on the persona of a contemporary artist's atelier. Only 1.2 x 1.8m, they provide tiny yet perfect workrooms for Artemis and Naos. Of course, the restricted space imposes limitations and forces them to keep everything simple and tidy, no matter how busy they are. However, within these bijoux buildings, the blog is still written several times a week, weaving projects are undertaken on small vintage looms, and antique clothing and textile items, sourced from car boot sales and flea markets, are expertly repaired and altered.

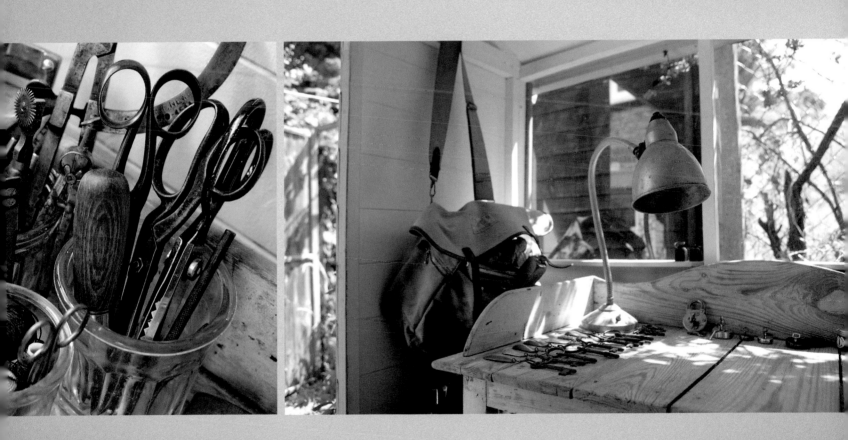

## style notes

This naturally stylish couple have crafted unique working environments from two common-or-garden sheds, which are positioned in such as way as to relate to each other with windows looking out over the backyard. Inside each shed, everything has its orderly place. Vintage reels of cotton thread on wooden spools are stored in jars that are decorative as well as functional. Surplus fabric is saved, rolled neatly in an artful fashion to be recycled at a later date into a bag, small purse or decorative piece. Nor are details of beauty and functionality overlooked: Artemis likes to work with pure cotton thread on vintage items rather than the modern polyester equivalent, which lacks integrity and does not 'sit' the same way on the cloth. Highly spun with a light sheen, it is incongruent with the subtle vintage textiles.

This love of detail and authenticity permeates everything this talented couple believe in, and a closer look at their sheds highlights the key themes of their taste and work – a love of Japanese style, small repeat flower prints, geometrics and pattern, mixed with 1930s and '40s English textiles. Ultimately, it is a balance of scale, repetition and tone that provides the keys to the Holy Grail of personal style, and it can only be achieved through developing and embellishing the minute details of your own genuine preferences and interests. But beware! These tiny beautiful spaces, huddled together in a diminutive backyard, can be deceptive. They look so appealing that you could be misled into thinking that they are all about beauty and leisure rather than the amazing output of high-quality work that is produced within them. These sheds are truly an inspiration to us all.

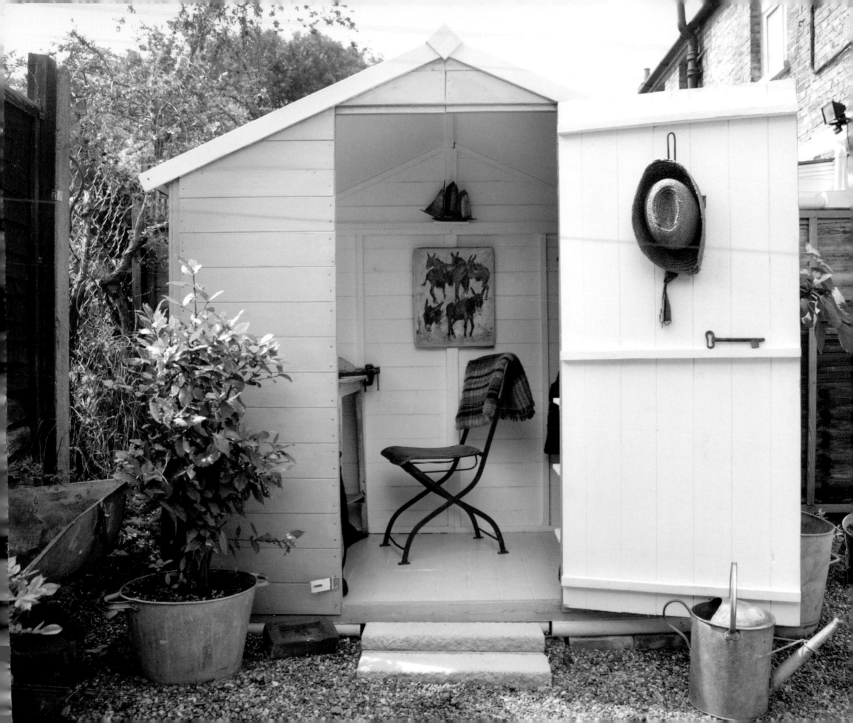

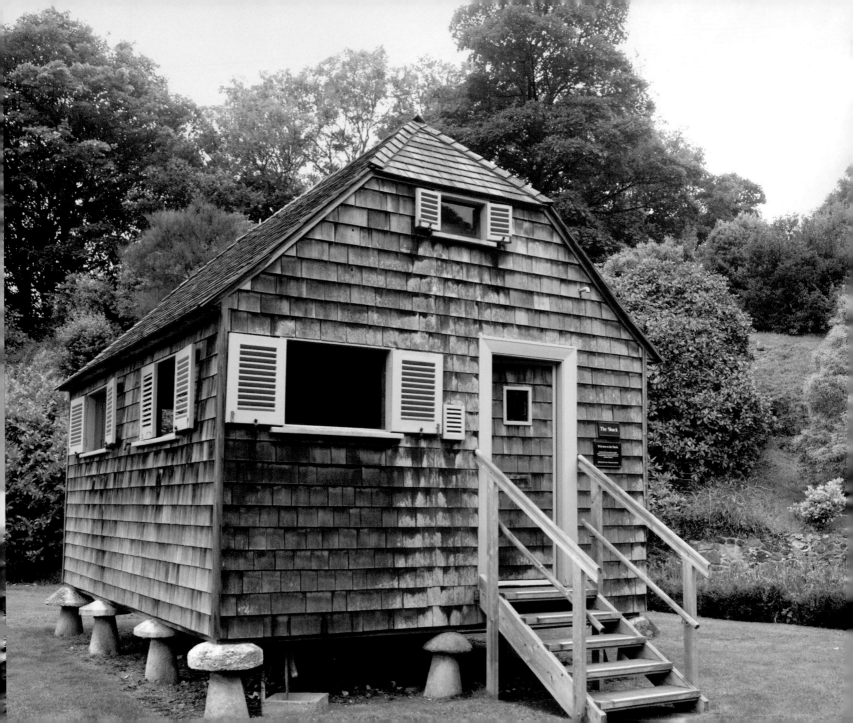

# the shack, mottistone

The Shack has changed little since the 1930s when it was built as the country cabin and summer drawing office of the architects John Seely and Paul Paget. It's a marvellous example of Modern Movement design, hidden away in the Mottistone Manor gardens, which were planted in an experimental twentieth-century Mediterranean style. Seely and Paget are probably most famous for Eltham Palace, their art deco masterpiece, and their restoration of St Paul's Cathedral after World War II. As their practice developed and flourished, they decided to design a rural retreat that would not only enable them to escape from city life but also serve as a temporary office and source of inspiration.

Constructed by the local building firm of J.R. Buckett & Sons, The Shack was initially sited on Freshwater Golf Course, overlooking the English Channel, but this proved too windy and it eventually found its final resting place on the former tennis court at Mottistone Manor in 1938, which was owned at that time by John Seely's father. As exponents of the 'modern' school, Seely and Paget used the project to create an architectural gem, incorporating their design principles and the most modern materials available.

Small but exquisitely precise in every detail, The Shack is so self-contained that it even has its own shower room tucked away at one end and a tiny kitchen at the other. Each architect had his own desk and bunk bed, while the central sitting area has a brushed stainless steel fireplace and flue with a facing pair of chairs by 'Plan & Parker'. The cedar shingles that cover the exterior from apex to base give the building a natural-looking eco-friendly camouflage, so it blends into the surrounding gardens.

Paul Paget (1901 - 1985) was the son of the Bishop of Chester. He began his working life as a bank clerk before being told by Seely: "Now we'll start the partnership...I can't possibly be an architect unless we make it a joint effort."

## style notes

The Shack has an overall warm, reassuring and sturdy feel. The choice of materials, internally and externally, gives it cohesion and makes it comfortable on the eye. The National Trust are the current owners and its careful restoration involved painting the exterior shutters their original colour of Farrow & Ball Nile Green. Whether intentionally or not, this complements beautifully the greenish weathering of the cedar shingles.

The interior is compact and practical, conveying the general feeling of a two-berth ship's cabin. The built-in furniture emphasises the important clean lines of the design as well as maximizing the functional use of the available space. Seely and Paget's choice of materials is limited, along with the colour palette, but it works well. The predominantly walnut furniture is a warm brown, creating a perfect harmony with the walls and ceiling, which are clad in Masonite, an American hardboard invented in 1924. Sleek and smooth, it gives The Shack its own distinctive 1930s splendour, as does the cork floor covering.

It is a symmetrical, seemingly simple space, and the ends of the building reflect one another. Two single bunk beds, each illuminated by an identical reading light, sit high under the eaves, accessed by a chrome tubular ladder, which was exceedingly modern for its time. Indeed, this innovative building was ground breaking in its use of modern materials and new technologies borrowed from other disciplines.

The overall impression is of an elegant cabin, which is redolent of 1930s style. Although it has minimal decorative detail, it is wonderfully well made and crafted with its beauty implicit in its structure, choice of materials and the thoughtful design of the totality of the space... the architecture speaks throughout.

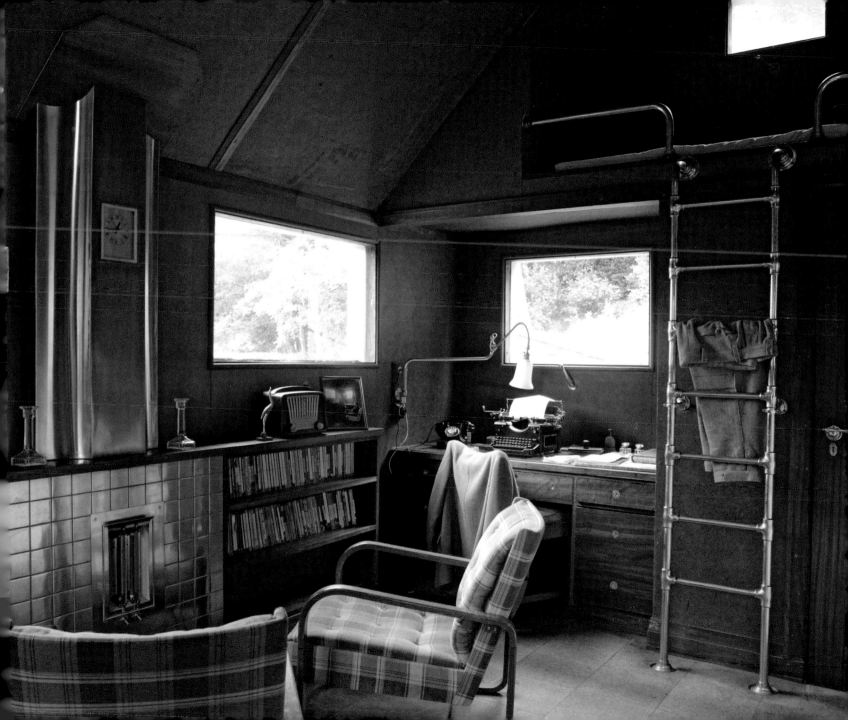

# village underground

Perched high above Shoreditch High Street and its tortuous one-way system in east London are four brightly coloured disused Jubilee Line Underground train carriages. The spectacular view from the driver's carriage is not for the faint hearted or sufferers of vertigo – you really feel what it must be like driving a Tube train with the outside world speeding past. Village Underground is a proud building project in the heart of London, providing a unique workspace for the urban creative community. It was originally conceived as an environmentally friendly and affordable studio space, where fledgling creative teams and freelance designers, writers, artists, musicians and filmmakers could work and be inspired by likeminded individuals.

Village Underground believes in reuse before recycling and the graffiti-covered railway carriages and accompanying shipping containers have been given a new life and purpose – sideways thinking has come into play in the most unexpected way, but one that sits incredibly well in its inner-city location. The driver's cab at the front, which is used as a meeting area, has a marvellous utilitarian design and is a work of art in itself, worthy of restoration. With its fascinating control buttons, old-fashioned telephone and graphic geometric-patterned 1970s moquette seat upholstery, you feel as though you are entering a time warp.

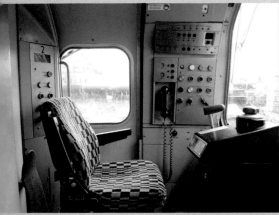

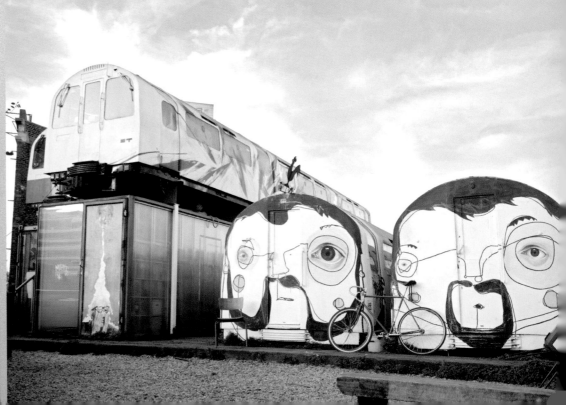

## style notes

These once hard-working train carriages now sit on an unused railway viaduct. This former subterranean space is itself an artwork with vivid, brightly coloured graffiti and old Underground maps used as blackboards. The original seats have been removed and replaced with narrow desks, while pot plants and orchids bloom among the laptops. It is untidy, for sure, but it's that lovely creative mess that happens when you are focused on your work ethic and wonderful new ideas and projects.

The Village Underground's green credentials are plentiful: this is an ecological project where all the flooring, furniture and staircases are recycled. The multi-functional living roof augments biodiversity, absorbs carbon emissions and provides effective insulation, thereby reducing fuel consumption and minimizing the impact of the building on the surrounding environment. The studios themselves are virtually carbon neutral, and solar power generates sufficient electricity for the lighting, machinery and office equipment. Extra power is supplied by 100 per cent green energy from wind turbines. It still feels cold on grey winter days but this minor drawback is more than compensated for by the benefits of the cross-fertilization of ideas when you find yourself sitting next to a creative artist from another discipline.

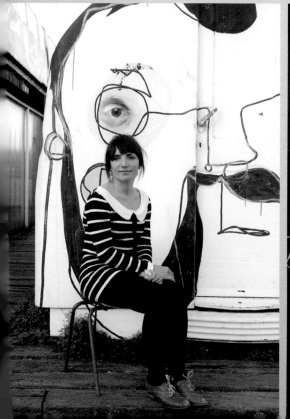

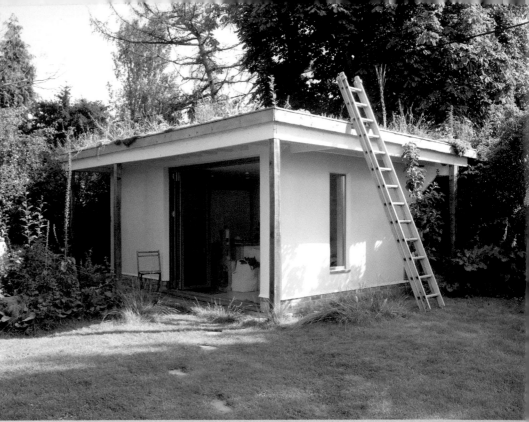

# the shoe-maker's shed

Alexei Gaylard started his eco-ethical shoe company in the way many of us do, working in his tiny spare bedroom at home, but he soon needed more space to grow and develop the business. His spacious garden provided the natural solution and his workspace is this self-designed, green-roofed, hempcrete-walled and lime-plastered workshop cum studio cum office space. It reflects his enthusiasm for all things ecological, which contribute, he believes, to a better and simpler way of life. For Alex, this is borne out of experience: with his background in manufacturing engineering, he spent many years working in India in shoe-making factories where the workers had finely-honed manual skills and used simple tools rather than highly mechanized machinery. His company now manufactures and sells footwear made from vintage fabrics with recycled leather straps and latex soles made from cut offs.

Alex was inspired by the self-build eco projects featured in television documentaries, and he relished the challenge of designing and constructing his own eco building. Its design, originally conceived as a sketch on the back of an envelope, was an evolving organic process in itself – for instance, the dimensions developed from the size of a set of folding doors that he purchased on an online auction website.

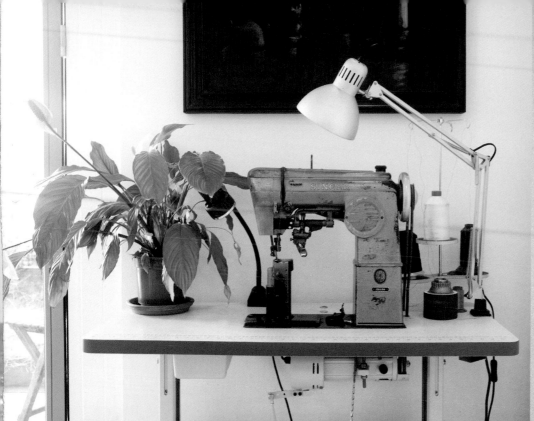

## style notes

Alexei's green credentials combined with his passion for sustainability and attention to detail have created a luminous and airy workspace. These qualities are also carried through into his business. This is a simple scrupulously honest building. Its modern airiness, together with the naturalistically planted overhanging roof, sits happily in its domestic garden setting.

The large folding doors face north, giving the space a pleasantly diffused light. On cold winter days, it is heated by a heat exchanger, which generates a comfortable warmth. There is an incongruity to the interior with its white walls and floor, clean minimalist décor and antique artefacts. The low-tech machinery for making shoes doubles up as part decoration. The 40-year-old classic Singer 'post bed' sewing machine, an internet purchase, sits on a pure white work bench below a dark, atmospheric painting by one of Alexei's friends – a still life arrangement of its own. On top of the cupboards perch sculptural shoe 'lasts' for storing ready-to-go soles and tools.

Many pieces of equipment are second-hand or hand-built, like a plywood sole press and an aduki bean filled, leather-topped pressure pad for making an inprint of a sole. All these satisfyingly low-tech solutions were designed by Alex and built by his father. The shed is a wonderful example of a hybrid enterprise of low energy and high creativity.

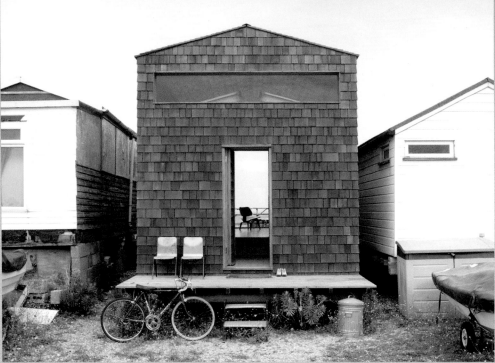

# beach hut

Nina Tolstrup, an influential product designer who lives and works in London's East End, missed the easy-going lifestyle of her native Denmark and set out to find a restorative hideaway, within an hour's drive of her home, where she could retreat and relax. She had no fixed ideas about what she was looking for – only that it should conform to her personal design ethic and it had to be useful. She considered buying a small cabin or even an orchard where she could park a vintage caravan but, flicking through an auction catalogue one day, she came across a building plot for sale on a beach in Kent, a perfect driving distance from London. In Denmark, beach houses are relatively commonplace, and to Nina this seemed like serendipidy. Her fate was sealed and she took the plunge, bought the plot and sold her flat in Copenhagen within a week.

With the plot secured, Nina's design credentials were put to the test. Her Danish upbringing had infused her with a quintessentially pragmatic approach to design. Her initial challenges were the limitations imposed by the size of the plot and the proximity of the neighbouring traditional huts. There were also strict building guidelines and her desire to maximize the views and spectacular light, as well as the small matter of how to get a kitchen, bathroom, sitting area and facilities for sleeping six people into a small space. Nina enjoys a challenge and she created a life-enhancing seaside escape, which feels spacious despite its sparse and minimalist interior. Her ingenious solution manages to sleep four on the upstairs mezzanine level with two children's bunk beds downstairs.

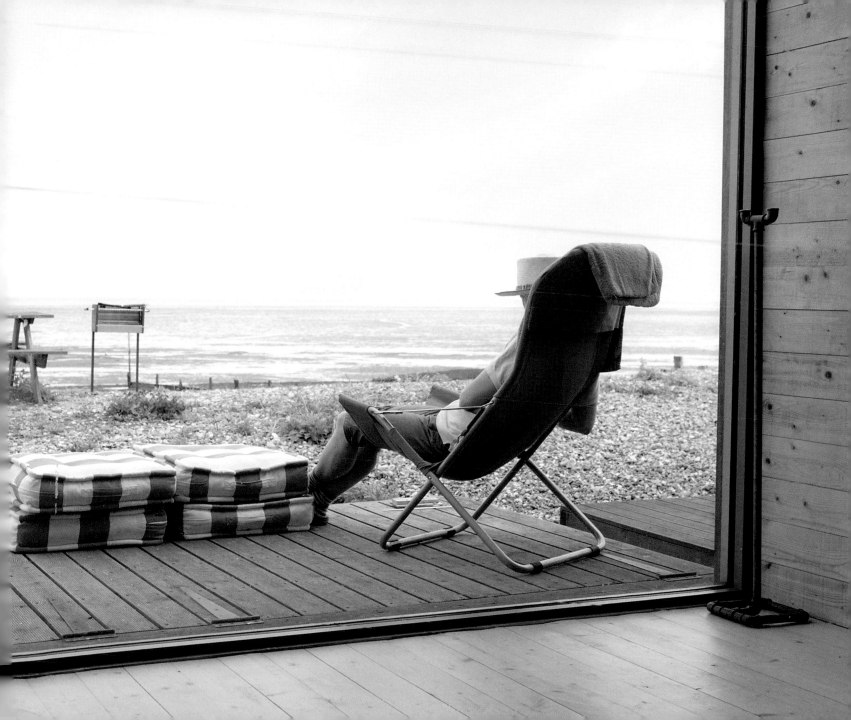

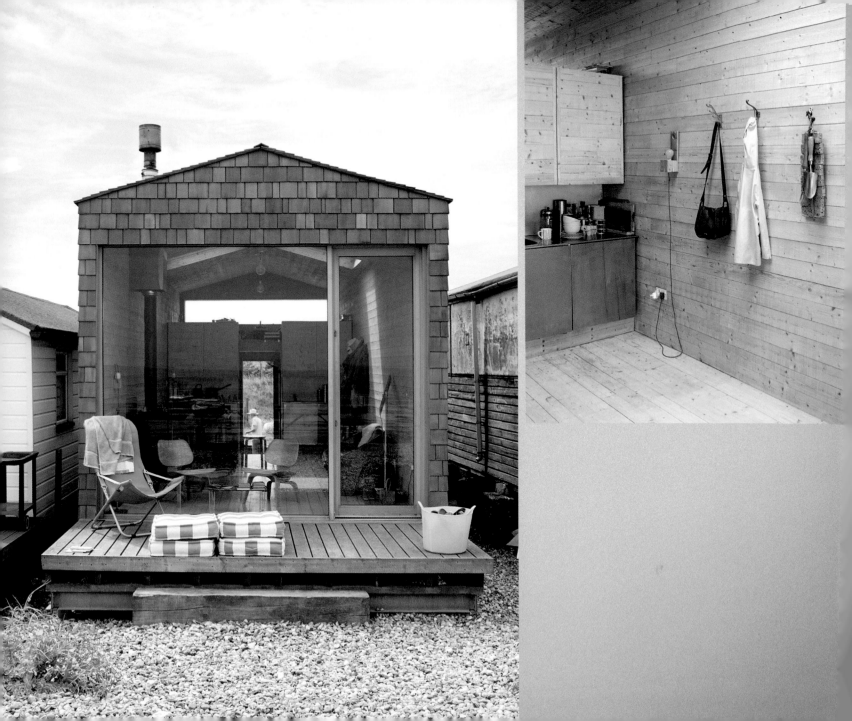

## style notes

Nina's beach hut is a simple, cohesive space, unified by a limited colour palette and the uniformity of the materials she has used. There is a purity to the external cedar shingle cladding and the interior floor, walls and ceiling, which are constructed from horizontally-set, rough sawn pine. It was painstakingly sourced and Nina loves the hand-hewn tactile quality of its surface texture. It exudes a feeling of enveloping warmth and fills the beach hut with the subtle aromas of freshly sawn wood.

The simple building has two enormous windows, both spectacular. The wall facing the beach is constructed totally of glass, with sliding doors, looking out onto the watery-grey Turneresque ever-changing seascape. The mezzanine sleeping area at the back has a long narrow window with lovely landward views over the shingle bank and the rolling green countryside beyond.

Wood is everywhere: in the storage units, cupboards and furniture, while a wood-burning stove keeps the beach house warm and cosy for use in the winter. The small wooden stools stack neatly to create more space, and there are hooks on the walls to keep the floor clear. A splash of bold colour is provided by the red moulded 1960s sofa, which Nina found in a London market. As soon as she saw it, she just knew she had to have it, it just said 'buy me – I'm perfect for a modern beach hut'.

# frinton beach hut

The instant allure of a row of gaily-painted beach huts isn't difficult to see, but for Johanna, buying her own hut has proved life changing. Only 30 minutes' away from where she lives, she has turned it into a cheerful daytime getaway – the perfect place for her children to play and embrace a healthy, outdoor life. One day, while out driving, she decided to chill out and enjoy the crisp, clear light and sandy beach at this old-fashioned, traditional seaside town. And, on an impulse, after peering in a local estate agent's window, beach hut number 345 was purchased, and within three weeks the property was hers.

However, the river of life does not always run smoothly and there were some initial setbacks. Unhappily, the beach hut was burnt down in an arson attack and Johanna had to start rebuilding it from scratch. In some ways, this may have been a blessing in disguise because it gave her the opportunity to recreate the hut and restore it to its former glory. She spent the next three years hunting down and gathering nostalgic objects and decorative pieces to give it back its original vintage feel.

A beach hut's appeal is timeless and idyllic, transcending generations and transporting us back in time to a quieter way of life that has long since vanished. As Johanna says: 'It's the ideal way to spend your childhood. My children love going to the beach, they've got loads of freedom, and the little one especially likes to build sandcastles and scooter up and down.' Whatever the weather and season, there is always something to do, whether it's minus five degrees and a biting cold wind or a still, baking hot summer's day.

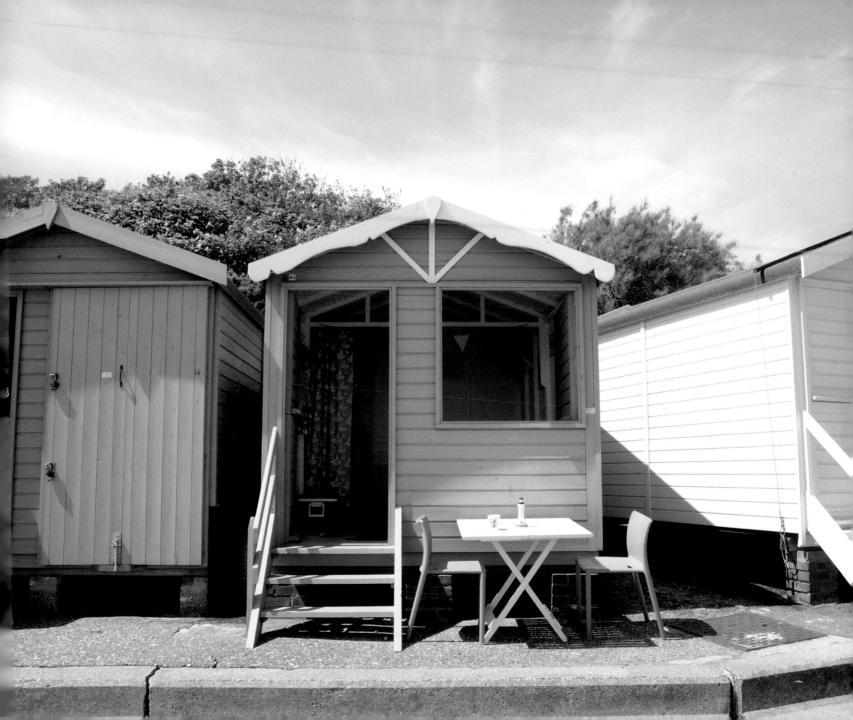

## style notes

Johanna has decorated and furnished the hut in a fresh and breezy seaside style. This can be difficult to achieve and many people fall into the trap of buying too many co-ordinating seaside or nautical themed items, which rarely creates a space that feels authentic. However, Johanna has successfully mixed old pieces of everyday family furniture, such as the lovely 1950s kitchen dresser and classic dining chairs, which she and her husband inherited, and has added some quirky individual pieces from junk shops, like the mugs. She has customized the dining chairs, painting the frames and recovering the seats with a modern child-friendly spotty fabric. This engaging eclectic mix of vintage and domestic family items has created the perfect retro style.

Embracing the challenge to decorate something other than your home empowers you to cut loose and have some fun experimenting with new ideas

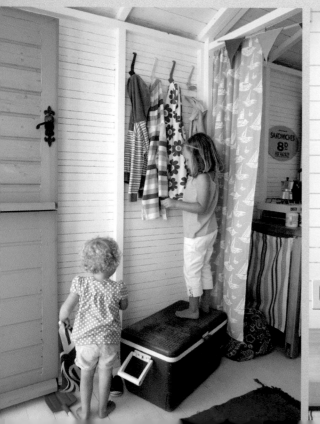
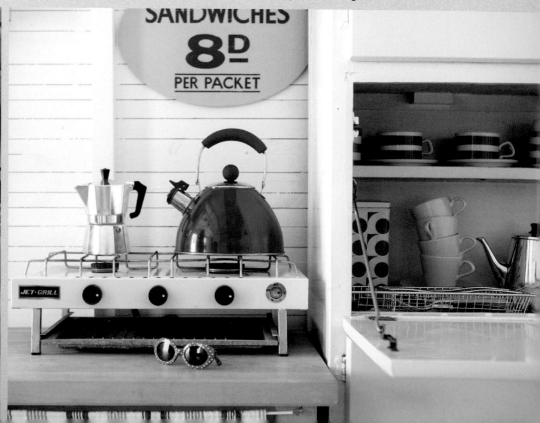

and styles. You can enjoy stepping outside your usual decorating spectrum. In this colourful beach hut, notice how the gorgeous sunny yellow of the 1960s formica kitchen table punctuates the blue-and-white colour scheme with a sharp freshness. Bold colour contrasts can be really effective and prove that it is best to be adventurous and not to restrain your colour palette too tightly. Also, adding some quirky touches, such as the vintage storage tins and royal memorabilia and souvenirs, provides interest and texture.

This beach hut works on so many different levels: it provides a fabulous space for the whole family to take a break from their normal domestic life and routine; it gives Johanna the opportunity to express her creativity; it has a nostalgic, vintage feel in a simple, fresh yet modern way – and it's all genuine and not contrived. This is truly an inspiration to us all.

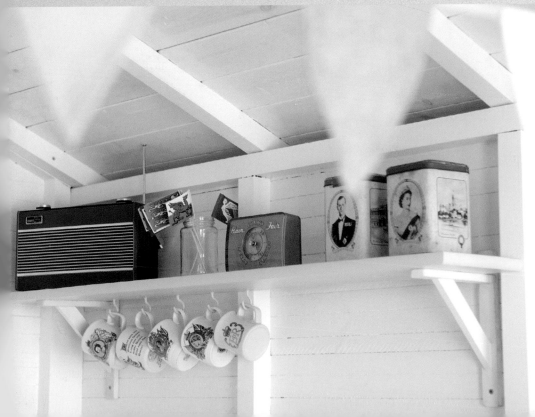

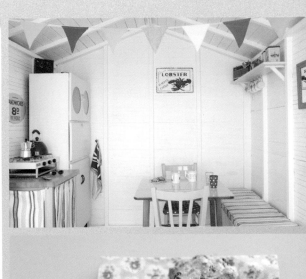

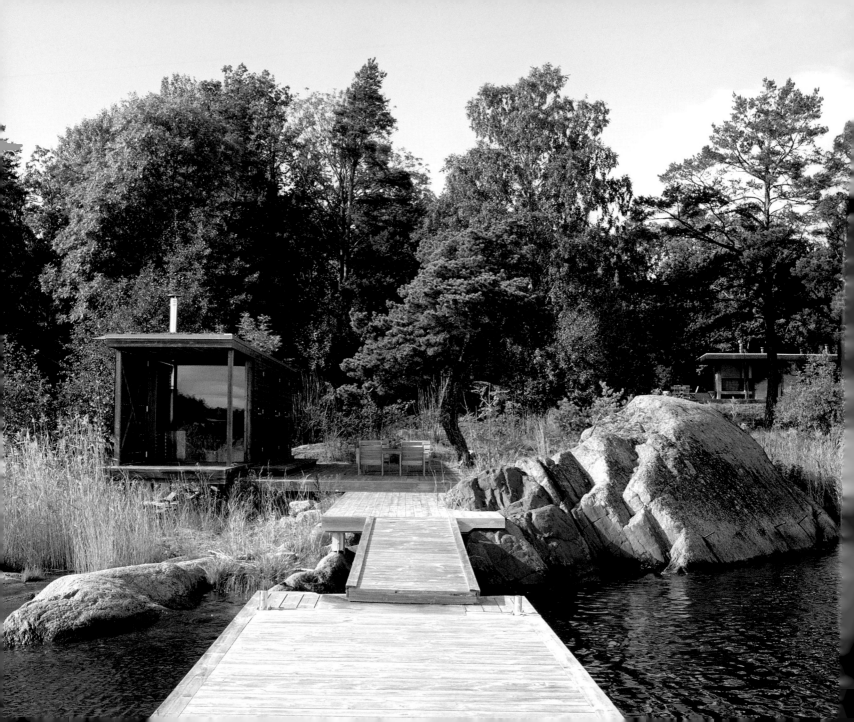

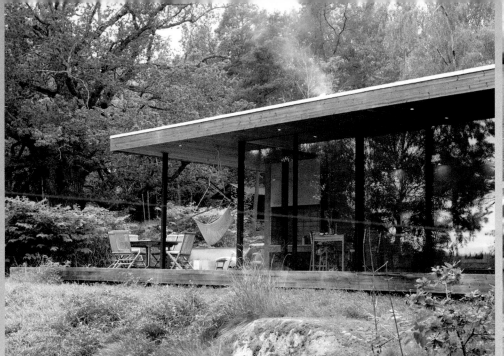

# swedish beach house

This fabulous waterside holiday home was built as a rural retreat on a remote island, but appearances can be deceptive and, in reality, it is only one hour's journey from the hustle and bustle of city life in Stockholm. The stylish wood and glass beach house is symbolic of simple, minimalist design, and blends seamlessly into the surrounding long grasses, moss-covered mounds and dark fir trees. An ancient 500-year-old oak with huge gnarled branches stands on guard beside the house, a natural survivor in a harsh landscape.

When the owners drew up the design brief, their focus was not only on planning a building that suited heir lifestyle but also on customizing it for their specific needs. Most importantly, they wanted a structure that was subtle and enabled them to be at one with nature rather than a building that was ostentatious or grand. The wooden deck area was custom-made to flow effortlessly around the existing rocks and boulders, and a separate wooden sauna, perched right on the water's edge, looks organic and totally natural.

The only access is from the water by boat, and, as you approach, the house looks small, unassuming, almost hidden. The owners use it as a summerhouse where they can escape from the city and chill out during the summer, although there is an infrequent ferry service throughout the winter, too. There are no cars or shops on the island, so they bring all their provisions, making it a true getaway where they can embrace a simpler, quieter life – it's not surprising that they never take their work there. It's a little paradise for their children and friends, who love to fish, splash around in the water, relax in the sauna, lounge on the deck or light up the barbecue.

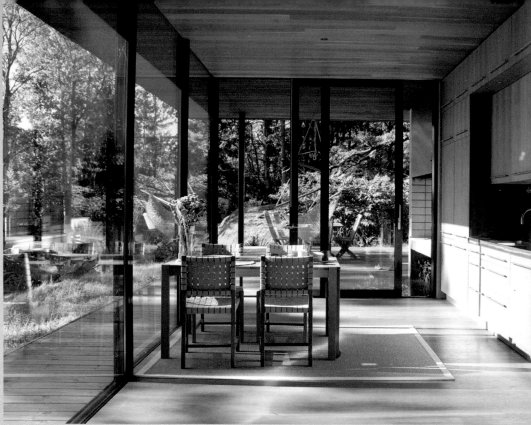

## style notes

The owners dislike clutter and they have created a separate 'bag' room just for all their everyday bits and bobs and 'stuff'. They prefer a sparse, clean and airy interior with all the visual drama on the other side of the large plate glass floor-to-ceiling windows. And while they are enjoying the spectacular views, the wildlife are peeping in and observing human life. This is the high-end designer re-invention of the archetypal primitive wooden shack in the wilderness, but living the good life is hard work: logs need to be chopped and maintenance tasks undertaken. It looks simplicity itself but it's not easy keeping the beach house so tidy, simple and clean.

To some extent, nature has played a hand in this building's design and structure: the exterior timbers, decking and wooden furniture have been allowed to weather to a natural palette. There are no fences, walls or man-made divides – the external boundaries are all natural and an intrinsic part of the environment. And when the landscape is so spectacular, there is little need for decoration or distraction; the emphasis is on just being. This is the perfect bolthole where the family can escape and spend quality time together in the massive kitchen/living area or outside on the deck. The bedrooms are simple, cabin-style rooms with sliding doors and big picture windows letting in the light and creating a bridge to the wilderness outside.

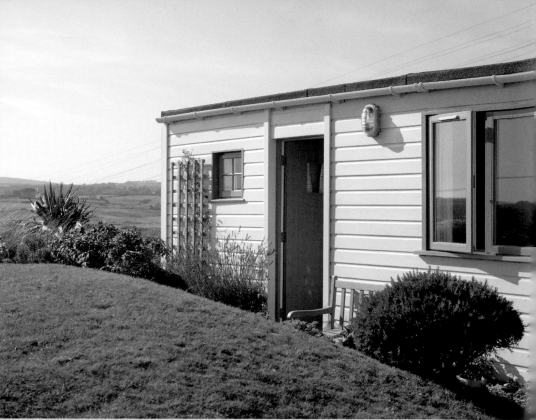

# cornwall beach chalet

Nestled among all this natural beauty where the undulating sand dunes are planted with gorse and marram grass, overlooking sandy surfing beaches, is a collection of holiday chalets. The area still bears the telltale signs of its industrial past, but the old pylons and former factories are being demolished and the focus is now on leisure.

The owners of this 1930s timber beach chalet have found the perfect retreat from the travails of daily life. Their main house is only a 15-minute drive away, so whenever possible they escape up here to their tiny bolthole on top of a sand dune, to enjoy that holiday feeling, even if it's only for a short period tacked on to the end of a working day.

When Angie and her partner discovered the chalet and fell in love with it, they felt overwhelmed by the sheer amount of work involved in carrying out a comprehensive renovation and decided not to go ahead and buy it. However, by the following year something had shifted subtly in their mindset and they both felt that their mutual need for a bolthole was stronger than ever. Instinctively, they knew they had to have it.

The work now done, Angie finds the place 'extraordinarily relaxing – it possesses a unique quality and from the moment we arrive we feel tranquillity and peacefulness'.

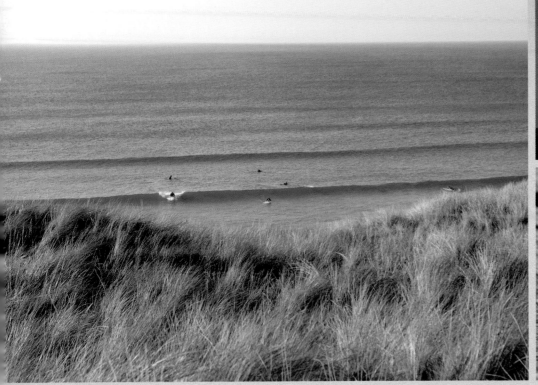

## style notes

Renovated throughout but retaining as much of the look and feel of the original building as possible, most of the walls have traditional tongue and groove panelling, both vertically and horizontally. Various owners, over the years, had attempted some modernisation, including installing plastic-framed windows and covering the original tongue and groove with sheets of hardboard.

Renovating and restoring a building sensitively is hard to get right, especially if you want to end up with a modern comfortable living space rather than a museum piece. Deciding which features to restore and which to replace needs careful consideration, and respect for the original building and its future use needs to be balanced. All these objectives been achieved here: the chalet feels contemporary without it overpowering the original charm of the building.

The interior of the cabin is tranquil and soothing. Angie's plan was to decorate it using the colours from the vast natural landscape right outside the door and this has worked exceptionally well. She kept the paint palette deliberately neutral, and soft tones and matt or semi-matt finishes are used throughout, thereby creating a relaxing, watery, morning light quality.

# mudgee permanent camping

Located on a remote mountain on a sheep station in New South Wales, this striking copper-clad building rises out of the Australian bush like a soft pink, elegant lookout station. Sited on the edge of a ridge surrounded by ancient dead trees, the tower has amazing views stretching for miles and miles all the way to the distant mountain ranges and horizon. Only the sky changes in this vast landscape – there is no other habitation.

Its owner, a graphic designer, purchased 2,000 acres of this magical wilderness where he could create a building that would recapture the wonder of his childhood camping trips. Conceived as a retreat for two people, the two-storey tower stands in an elevated position in its copper-walled armour. The walls of the lower floor can be flung wide open, transformed into awnings and revealing the simple, stylish interior. Nothing in this building's execution happened easily and it took considerable planning. All the materials had to be brought in specially, and since no builder could be found to carry out the work on site, the modest 3 x 3m hut was prefabricated and trial-erected elsewhere before the owner could achieve his goal of permanently camping in the wilderness. It is cold in winter and hot in summer; the land looks bruised and poor, supporting only subsistence farming. This is not a kind place and it asks a lot of anyone who would stay there. However, the owner sees this as a unique opportunity to 'chisel back to the essence of life itself'.

## style notes

There is a harmonious relationship between the three key elements of this hut: nature; the materials selected for the exterior and interior; and the structure itself. The materials are all on show – nothing is painted or disguised and the gradual ongoing process of their weathering can be enjoyed. Corrugated copper sheet has been used to clad the exterior, while the frame of the building is made from recycled ironbark, a tree related to the eucalyptus with natural fire-resistant qualities. When the tower is occupied, the walls on three sides of the lower floor open up, via simple pulleys and guy ropes, to provide a gigantic canopy, which is reminiscent of a tent awning. When unoccupied, they close down, thereby making the building appear impenetrable and offering some protection from bush fires.

The deck living area has elementary cooking and washing facilities, with a simple kitchen at the rear, equipped with a gravity-fed water supply and an exterior tank that connects to the tap. The sink is removable and can be replaced by a cooker that runs on bottled gas. The simple cookware in red, black and steel is in keeping with the overall visual scheme and practical approach. Tough colours and materials keep the palette tight and retain the rustic, camping feel. All the furniture sits low to the ground and is simple and squared off – like camp beds.

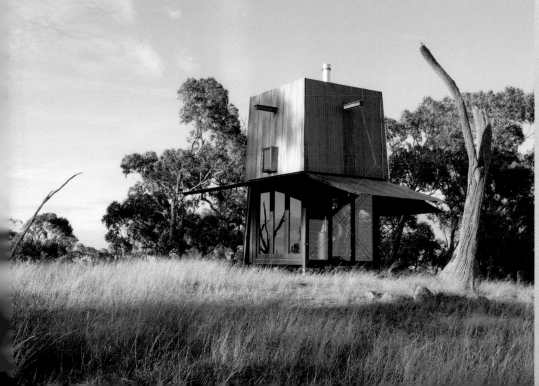

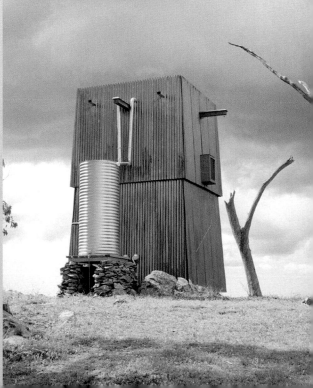

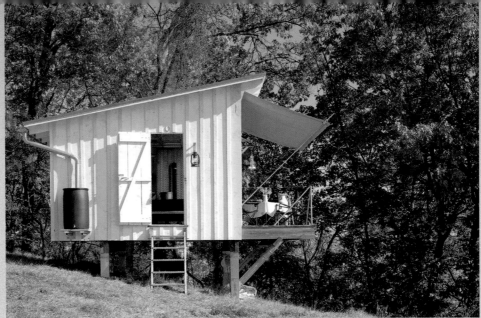

# the shack, west virginia

A camping trip in West Virginia initiated a project to construct a weekend retreat from city life. The 250 acres of mountain property with an isolated, supposedly haunted, farmhouse belonged to a neighbour of the Washington DC based architect Jeff Broadhurst. He fell in love with the natural beauty and remoteness and planted the germ of an idea with 'If you are ever interested in selling a piece of land...' Several years passed before this dream became a reality and Jeff and his wife eventually chose their plot in a tranquil meadow, some 400ft below the summit of South Fork mountain with sensational views across the valley.

They became the proud owners of 23 acres of land and 40 grazing deer, and Jeff immediately set about designing their shack. They wanted a structure that could be built inexpensively and which they could build themselves at weekends. What started as an initial design hastily sketched out on a napkin gradually took shape and the project started in early 2002. However, the Shack was not completed for another four years as, due to the bitterly cold winters in this area, the building work could only be carried out at weekends from spring through to autumn, using the sweat and labour of family and friends.

There were several prerequisites: the Shack not only needed to be comfortable, homely and accommodate four people but it also had to be self-contained, in terms of utilities, and raised off the ground to prevent snakes and mice making it their home. It had to be sturdy and able to cope with sub-zero winter temperatures as well as secure enough to deter local big black bears. Finally, Jeff wanted it to sit well in the landscape, blending in and making full use of the spectacular location. Happily, the end result fulfils all of these needs.

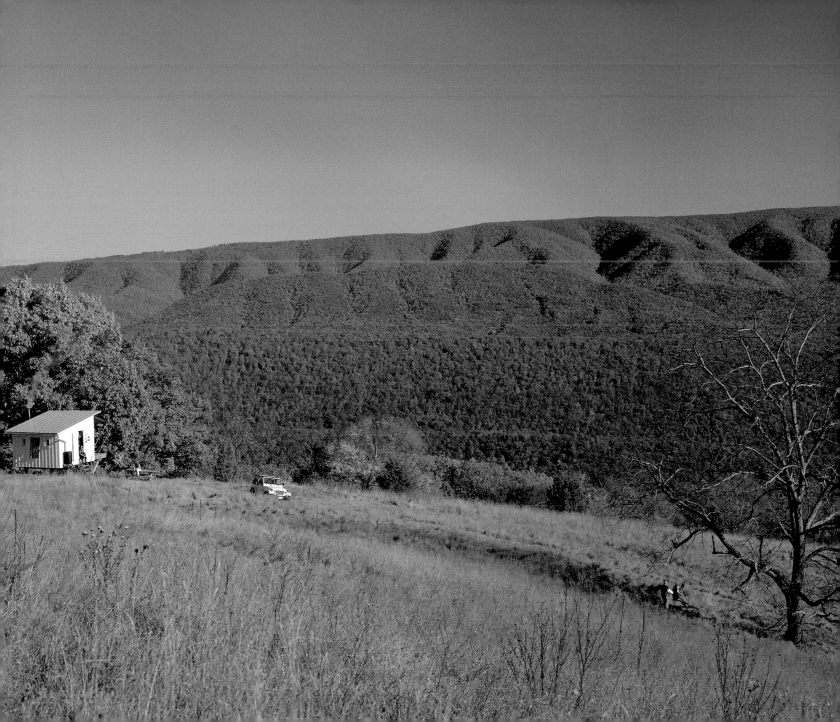

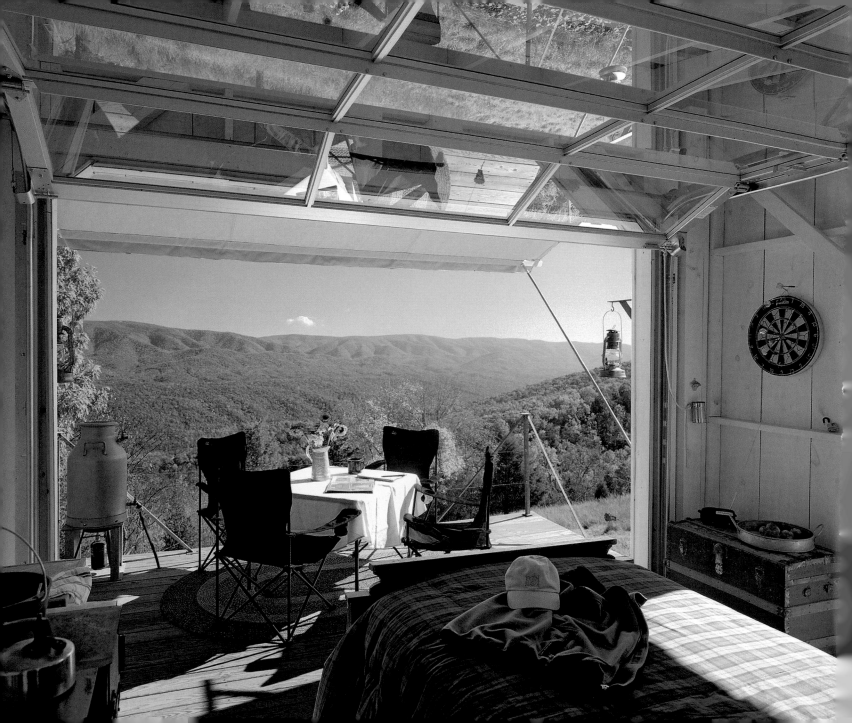

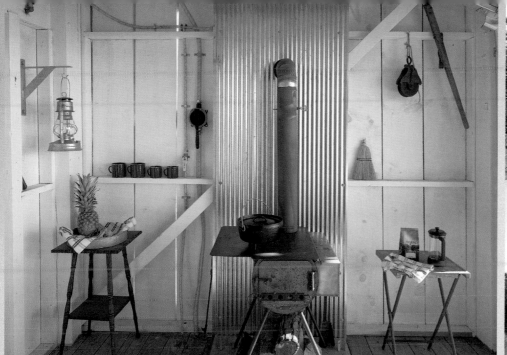

## style notes

This small shack is a mixture of simple, honest design and thoughtful solutions to the challenges of the environment, providing a comfortable lifestyle in an isolated rural landscape. Size can be deceptive and although it is tiny, it feels much bigger because the whole deck area opens up in summer by means of an ingenious rising glass garage door. Designed and made by a sail maker, a removable simple canvas awning, fluttering in the breeze, extends the living space yet further and provides welcome shade from the hot summer sun and shelter from the rain – Jeff describes this as one of his best ideas ever.

The Shack is a totally wooden structure, with pressure-treated pine floors throughout and walls constructed of locally milled pine boards, which have been painted white inside and out. It has no electricity and a simple woodstove heats the water and the building, while a small oven has been added to the stove, so the family can cook pizzas and even brownies. There is a small 'kitchen' equipped with a hand-powered bilge pump and a cooler filled with ice. Oil lamps are used to light the interior of the Shack, and an outdoor gravity-fed shower has been created, using a modern 10-gallon steel milk churn, heated by propane gas, as a water tank.

There is a simple, pure elegance to this building, which has been hand-crafted by Jeff and his family, and the original pioneering spirit of the early American settlers finds resonances in its design. This unique off-the-grid shack provides the perfect weekend retreat, which Jeff sums up as 'a logical step between tent camping and the as-yet-unrealized weekend cottage'.

# credits

We would like to thank all the shed and cabin owners for allowing us
to photograph their 'cool sheds'.

Front cover Johner/Wildcard Images UK
Endpapers by Louise Begby, photographed by Richard Maxted
(Agents Greenhouse (NYC) - 212 704 4300)
All other photography by Tina Hillier unless otherwise stated.
www.tinahillier.com

## artists

## musicians

## retreats

## gardeners

## writers

## workspaces

## time out

# acknowledgements

I would like to thank the many shed and cabin owners who have contributed to this book. They have happily shared their time with me and have allowed me to explore their creativity.

Tina Hillier's photography illustrates the truly emerging talent that she is, always developing and using her eye to produce shots that are worthy of serious acknowledgement.

Special thanks need to be given to The National Trust, Tate St Ives, the Barbara Hepworth Museum and Sculpture Garden and Bowness, Hepworth Estate, The Foundation Le Corbusier, ADAGP, Paris and DACS London for their invaluable assistance and co-operation.

My thanks to Fiona Holman, editorial director at Pavilion Books, for her consistent support and encouragement, and to Georgina Hewitt, senior designer.

Finally, thank you to Robert Lewis, my ever-supportive husband, and my team, Emily Lutyens, Nicola Barnes and Heather Thomas, for their constant help, enthusiasm and encouragement.

## jane field-lewis

Jane Field-Lewis is a London-based art director and stylist working in film and photography. With her *my cool* series, she has inspired a move towards a more authentic retro-decorative style that fosters individuality and accessibility.

**Additional captions: page 1 studio above the sea; pages 2–3 the shack, west virginia; page 4 californian art studio; page 6 shed songs ; page 9 tree houses; pages 10–11 studio above the sea;  pages 42–43 songs from the shed; pages 52–53 the wheelhouse; pages 84–85 william morris's garden shed; pages 98–99 george bernard shaw's writing hut; pages 112–113 hackney shed; pages 134–135 frinton beach hut; page 160 fishing shack**

First published in 2012 by Pavilion Books
An imprint of Anova Books Company Ltd
10 Southcombe Street
London W14 0RA

www.anovabooks.com

Commissioning editor Fiona Holman
Photography by Tina Hillier
Styling by Jane Field-Lewis
Design Steve Russell
Editor Heather Thomas, SP Creative Design

Text copyright © Jane Field-Lewis 2012
Design copyright © Pavilion Books 2012

A CIP catalogue for this book is available from the British Library

ISBN 978-1-862-05933-7

10 9 8 7 6 5 4 3 2 1

Colour reproduction by Dot Gradations Ltd, UK
Printed and bound by 1010 Printing International Ltd in China